IMAGES
of America

CENTRAL COAST
MOTOR SPORTS

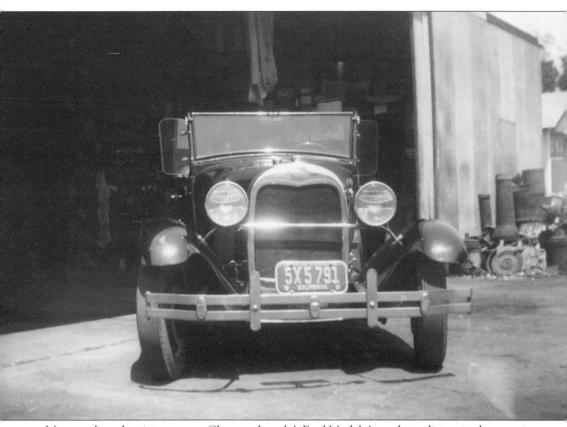

Motorcycle and sprint car racer Clarence Langlo's Ford Model A roadster glitters in the morning sun while parked outside of his garage on Ontare Road in Goleta sometime in the 1930s. The car is now owned and driven by his son Ed and is seen regularly at local car shows, while Clarence's other son, Arley, is a member of the vaunted 200 MPH Club and is currently preparing for another record-breaking attempt at Bonneville. This image illustrates the long tradition of motor sports in the Central Coast, where racing is truly a family affair and often crosses generations. (Courtesy of Ed Langlo.)

ON THE COVER: A Ford Model T races past the grandstand at Lompoc Rodeo Grounds around 1947. (Courtesy of Walter Schuyler.)

2017

IMAGES
of America

CENTRAL COAST
MOTOR SPORTS

To Pat

Tony Baker

ARCADIA
PUBLISHING

Published by Arcadia Publishing
Charleston, South Carolina

Printed in the United States of America

Library of Congress Control Number: 2016960999

For all general information, please contact Arcadia Publishing:
Telephone 843-853-2070
Fax 843-853-0044
E-mail sales@arcadiapublishing.com
For customer service and orders:
Toll-Free 1-888-313-2665

Visit us on the Internet at www.arcadiapublishing.com

Dedicated to Jerry Gaskill

CONTENTS

ACKNOWLEDGMENTS

First of all, I would like to thank all the good people of the Central Coast motor sports community for allowing me to rummage through their photo albums, scrapbooks, and, most importantly, their memories. Special thanks go to my friends Sam and Terri Foose for having me in their house so many times; to Will Schuyler for the gracious hospitality he showed me while I was in Lompoc; to John "Bat" Masterson for his vast photograph collection and all the stories he told me; to Fred Dannenfelzer, Seth Hammond, Arley Langlo, and the rest of the 200 MPH Club; to Don Edwards for his enthusiastic support; and to Mark Mendenhall for maintaining his wonderful archive. Thanks also go to those who contributed images and/or stories, Barry Atsatt, Joe Avila, Roger Battistone, Chuck Bohl, Lee Hammock, Stu Hanssen, Ed Langlo, Lee Ledbetter, and Bob Mostue. Thanks go to Desiree Gonzales, who edited and proofread the draft; to Gil Trevino, who processed the images; and to the staff at Arcadia Publishing. And of course, thanks again go to my family of friends who have supported and encouraged me throughout, my son Thomas, my old friend Harry Mishkin, the Ventura hot rod community, and to Adam, Tiffany, and Josh at Squashed Grapes Wine Bar and Jazz House, long may they pour. As always, every effort has been made to make this an accurate book, so please forgive the inevitable errors that will occur.

INTRODUCTION

While the explosion of automotive culture in the United States during the 20th century reached every part of the country, the population of California's Central Coast was particularly enthusiastic about it. The region, from Ventura County stretching north to Monterey and Big Sur, was blessed with an almost perfect climate for driving and a wide variety of excellent roads. Driving for pleasure became a regular leisure pastime, and driving for sport quickly followed. A whole industry revolving around modifying and customizing Detroit's products to suit the tastes of California drivers grew up in the region and still exists today. Small dirt racetracks were present in most cities and towns throughout the mid-20th century, as were drag strips. And every neighborhood had at least one teenager who spent his time in the family garage with his buddies building a hot rod. That's really where the whole thing started. In both the cities and the small towns along the coast, a homegrown culture dedicated to all things automotive began and continues from generation to generation.

The story of Sam Foose is an example of how the movement started. As a teenager growing up in Santa Barbara, while sweeping floors part-time in a body shop, he learned bodywork by watching his employer and going home to practice the trade on old pieces of metal in his parents' garage. Sam would go on to become one of the finest automotive customizers, fabricators, and especially painters of his era. His son Chip Foose followed in his father's footsteps to become an internationally known automotive designer and is also well known for his philanthropic efforts.

Motor sports on the Central Coast grew organically, with localized scenes sprouting up all over the area. In the small town of Lompoc, during the Great Depression of the 1930s, a group of young men started their own low-cost motor sport. Using stripped-down Ford Model Ts, which were available then for practically nothing, they formed a club and began racing. First cross-country and later on dirt ovals, the events went on for over a decade and attracted thousands of people.

Somewhat more costly forms of motor sport that have been very popular on the Central Coast are drag boating and hydroplane racing, both in the ocean and on the numerous lakes and reservoirs that were put in during the postwar years. One local who became one of the winningest drivers in the sport is Don Edwards. An enthusiastic supporter of drag boating and a great competitor, Don also had a hand in furthering the technology of the sport by building an innovative boat that could have been the fastest in the world.

Cosmopolitan Santa Barbara has always been popular with tourists, especially from the UK and continental Europe. The population there is generally well educated and cultured, the climate sublime, and the scenery beautiful. Starting in the early 1950s, a European-style road racing scene began at Santa Barbara Airport that lasted for over 20 years. A colorful mix of homebuilt race cars and the best that Europe could produce, the races were glamorous affairs that attracted many celebrities as well as a strong local following. Airport expansion in the late 1960s put a stop to a vibrant scene that would probably still be going on.

Speed has always been the primary motivating factor in the various motor sports. To be the fastest of all is the ultimate goal. The venue for that pursuit has been a dry lake known as Bonneville

Salt Flats, in the state of Utah, where a group known as the 200 MPH Club was formed consisting only of those who had set speed records on the lakebed. It comes as no surprise then that a sizable number of the club's membership hails from the Central Coast region. A large group from the area makes the trek every year to Bonneville for Speed Week hoping to break yet another record.

While public interest in motor sports has declined somewhat from the glory days of the 1950s and 1960s, it has never died out, and certainly not on California's Central Coast. Santa Maria Speedway still holds races every season, and the dirt track at Ventura, known as Ventura Raceway, is still doing business. There is talk of building a drag strip and motor sports park in Lompoc, and car shows throughout the region are still well attended. Whatever the future of motor sports may be, in California it has certainly had a rich and colorful past.

One

SAM FOOSE, MASTER CRAFTSMAN

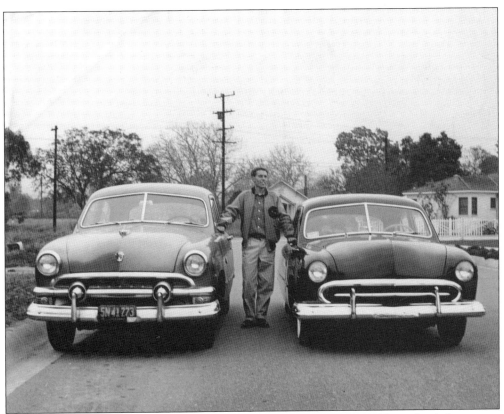

The Central Coast's foremost customizer is the great Sam Foose, pictured here. Sam's designs are known for their clean and subtle, smooth-flowing lines, unlike the more flamboyant creations of his contemporaries George Barris, Ed "Big Daddy" Roth, and Dean Jeffries. A master at design, bodywork, and fabrication, and especially talented at custom paint, Sam (Santa Barbara High School, 1953) has been building custom cars since his early teens. Sam is seen here posing with a before-and-after comparison of a stock 1951 Ford and his spin on the design, a custom known as the "Section." (Courtesy of Sam Foose.)

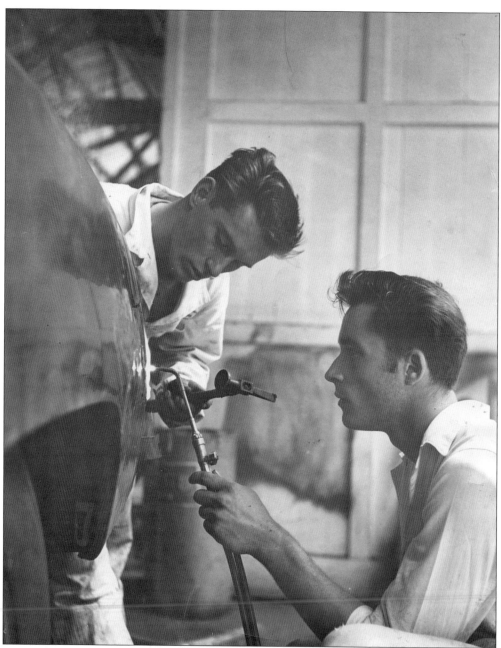

Sam began his career at age 13 sweeping the floor at Mel Riles' Body Shop on Milpas Street in Santa Barbara. After observing Riles at work, Sam began practicing on old fenders at home and soon became remarkably skilled at bodywork himself. When shown a sample of the young Foose's work, Riles immediately offered him a position as a body and paint man at the shop. Sam is seen here in 1952 with shop helper Gary Henshaw (at right) engaged in the old-school technique of shrinking the metal of a fender by alternately heating and hammering it. Still in high school when this image was taken, Foose was already becoming famous for his design and fabrication skills. (Courtesy of Sam Foose.)

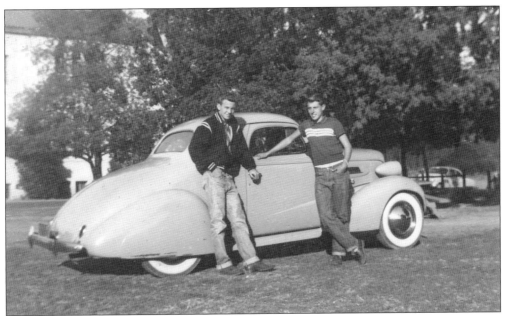

A native of Long Beach, California, Sam moved to Santa Barbara with his parents at age nine. This image from 1949 shows 15-year-old Sam (right) posing with an unidentified friend in front of a baby-blue custom 1937 Chevrolet at La Cumbre Junior High School in the late 1940s. (Courtesy of Sam Foose.)

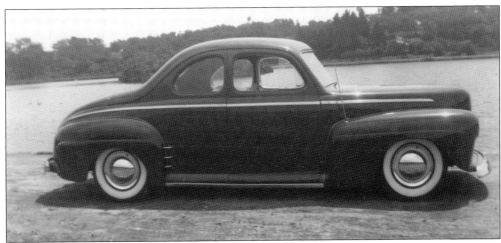

One of Sam's early creations was his 1942 Ford business coupe, pictured here in 1953. Sam "zee'd" the rear frame and installed a six-inch-drop front axle to lower it. He then took it to Rip Erickson's shop in Santa Barbara for the framework. The bright orange paint job appears much darker because of the orthochromatic camera film the image was taken on. (Courtesy of Sam Foose.)

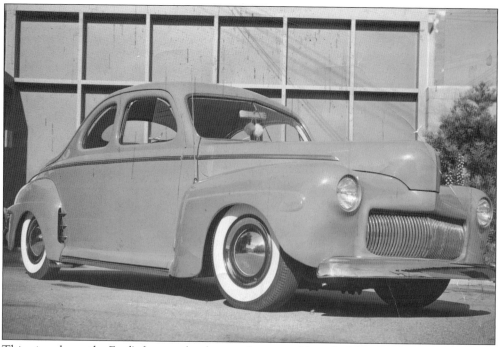

This view shows the Ford's front end to better advantage. Note the Mercury quarter-panel vents Sam installed ahead of the rear fender. They were functional and helped cool the big drum brakes. Along with the usual frenching, nosing, and decking, the bumper bolts have been cut and filled. The center piece of the grill was removed and extra grill bars were added to give the front end a Mercury-like look. (Courtesy of Sam Foose.)

The car's bright orange paint scheme carried on into the interior. Gutchel's Upholstery in Santa Barbara installed the eggshell-white tuck-and-roll vinyl and orange carpeting. The headliner was orange velvet. Everything on the orange dash was rechromed, and the steering wheel and column are Mercury items. In the early 1950s, the column-shift was a fairly recent innovation. (Courtesy of Sam Foose.)

This maroon 1946 Ford was one of Sam's rides while he was in high school. Sam frenched and filled most of the body and then added some of the trim from a 1948 model to update the look. The young lady is Sam's first girlfriend, Greta Whitehart. The location is Santa Barbara High School, and the year is 1950. (Courtesy of Sam Foose.)

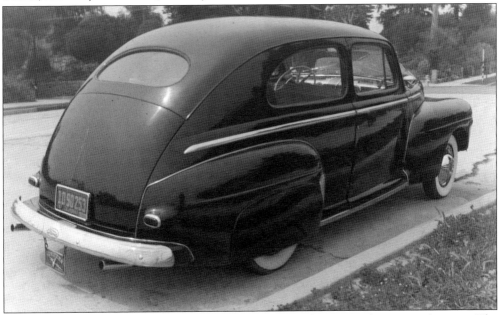

The taillights were lowered and Frenched into the rear fenders, as can be seen in this view. The fender skirts and decked trunk lid enhance the lowered appearance of the Ford Tudor. Note the Santa Barbara Igniters car club plaque attached to the rear bumper. (Courtesy of Sam Foose.)

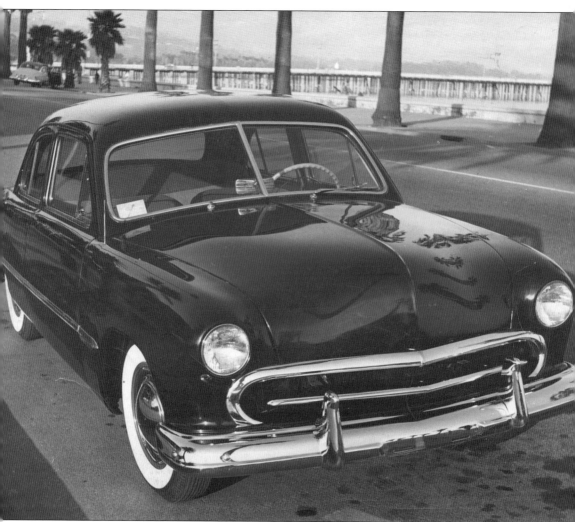

Sam's most distinctive early design was this beautiful, dark-green Ford-based custom he called the "Section" from 1953. Taking a wrecked 1949 Ford, Sam combined it with pieces from a 1951 Ford to produce the car shown here. Radically sectioned and lowered, the custom bears a strong resemblance to later European designs like the Borgward Isabella saloon and the German Ford Taunus. It certainly shows Sam's penchant for clean, simple lines. The Section was involved in an accident and later sold down in Los Angeles. The location is Wes Cabrillo Boulevard in Santa Barbara, with Stearns Wharf visible in the background. (Courtesy of Sam Foose.)

Here is an example of Sam's bodywork prowess. Done just before Sam was drafted in 1955, this metallic bronze Austin-Healey "bugeye" Sprite was given a completely new look. The headlights were replaced with smaller units molded into the front of the fenders. The grill opening was extended about 12 inches and reduced in size for a "mini-Ferrari" look. (Courtesy of Sam Foose.)

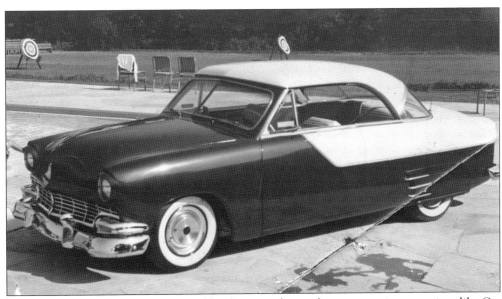

Sam customized this Ford in 1957, and by that time, his work was appearing magazines like *Car Craft* and *Hot Rod* on a regular basis. The maroon-and-white 1951 hardtop has been nosed, decked, and frenched, and nonfunctional air scoops were added above the headlights and forward of the wheel wells. The grill is a reworked 1956 Ford unit. (Courtesy of Sam Foose.)

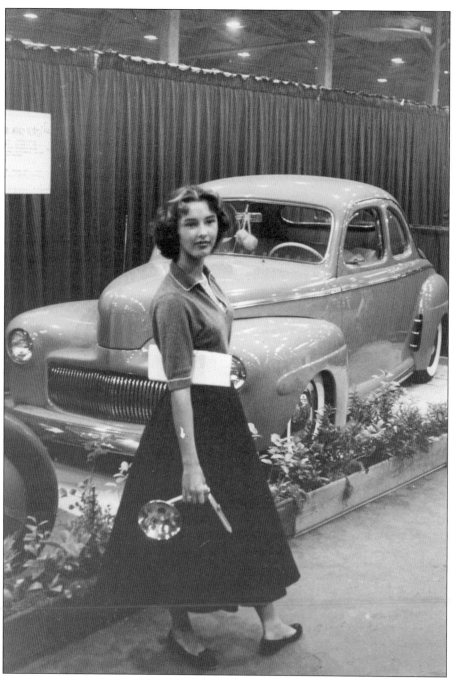

After leaving Riles's body shop, Sam rented a garage and worked for several years on his own, performing virtually every job in the shop himself. His custom work was being seen in hot rod magazines on a regular basis as he honed his skills. This image was taken at the 1957 Motorama Car Show in Los Angeles, a big event for car buffs in California and all over the West. Sam Foose's orange 1941 Ford made an appearance there that year alongside cars by George Barris, Dean Jeffries, and other big names in the movement. That is Sam's girlfriend at the time, Marty Flynn, nonchalantly crossing in front of the camera. (Courtesy of Sam Foose.)

In 1962, Sam went to work for customizer Gene Winfield, building special cars used in movies and television. Working as part of Winfield's team of skilled craftsmen, Sam built cars like this Western-themed Chrysler convertible for the short-lived comedy series *The Hero*, on NBC and starring Richard Mulligan. (Courtesy of Sam Foose.)

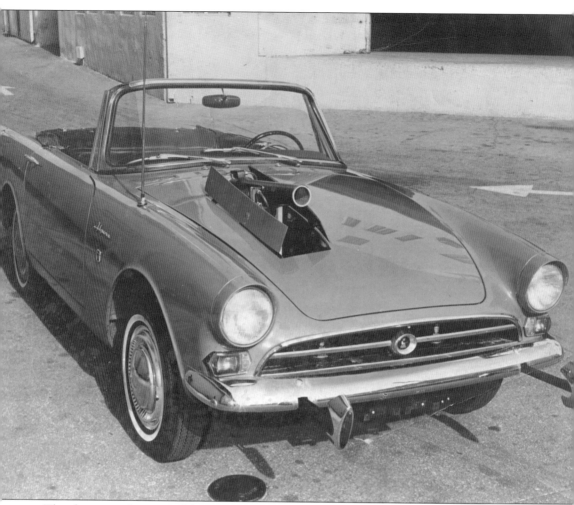

The phenomenal success of the James Bond series of spy films in the 1960s led to many imitators, both in the movies and on television. One of the best known was *Get Smart*, a comedic take on the genre created by Mel Brooks and Buck Henry for NBC and starring Don Adams as the inept secret agent Maxwell Smart. And while James Bond drove a glamorous, specially equipped Aston-Martin DB5, Maxwell Smart fought evil in this Sunbeam Alpine. Gene Winfield and Sam Foose customized the little Rootes Group roadster with the requisite spy gadgets like bumper rams, smoke ejector, and a small cannon that emerged from the hood via a scissor jack. (Courtesy of Sam Foose.)

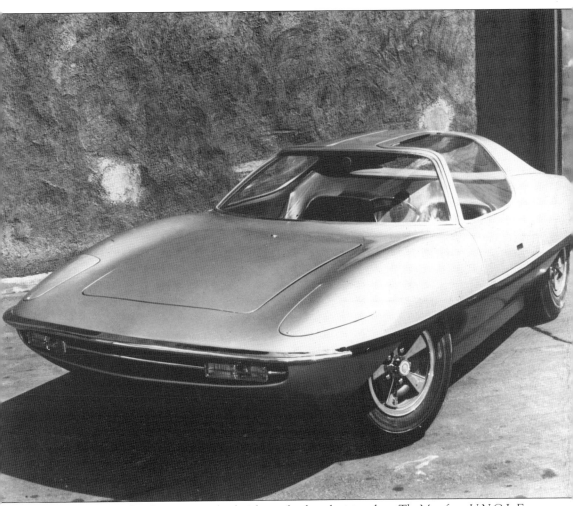

Another "spy car" that Sam was involved with was for the television show *The Man from U.N.C.L.E.*, again for NBC, and starring Robert Vaughn and David McCallum. In 1964, Winfield had established what was known as the Speed and Custom Shop for the AMT Corporation, in Phoenix, Arizona. There, he fabricated one-off, full-sized prototypes of functioning cars that AMT would use to promote the plastic scale-model car kits the company produced. One of the cars he was working on, the Piranha, pictured here, was tapped as the futuristic ride of *The Man from U.N.C.L.E.*'s lead characters. (Courtesy of Sam Foose.)

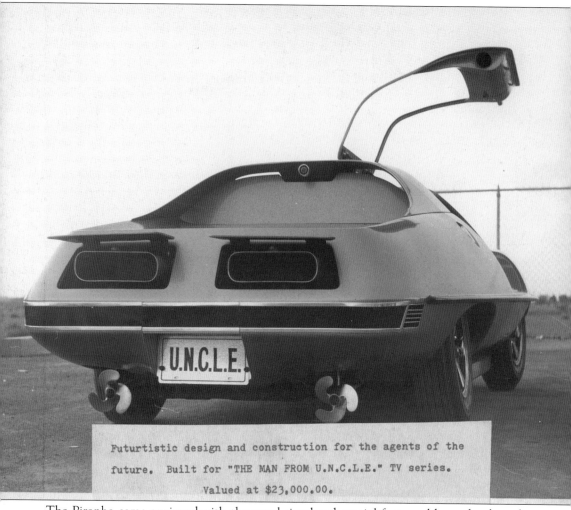

Futurtistic design and construction for the agents of the
future. Built for "THE MAN FROM U.N.C.L.E." TV series.
Valued at $23,000.00.

The Piranha came equipped with the usual simulated special features like rocket launcher, flamethrower, radar screen, and a host of other gadgets. The AMT Piranha was designed by Dann Deaver and was originally built to promote a new ABS plastic material called Cycolac, manufactured by Marbon Chemical. The body was entirely made of thermoformed Cycolac, and the chassis tub was fiberglass with front and rear suspensions attached via tube-metal subframes. Power was supplied by a Chevrolet Corvair air-cooled flat-six engine. AMT acquired the rights to build the Piranha from Marbon and produced a very successful dragster version, as well as one for regular street driving. (Courtesy of Sam Foose.)

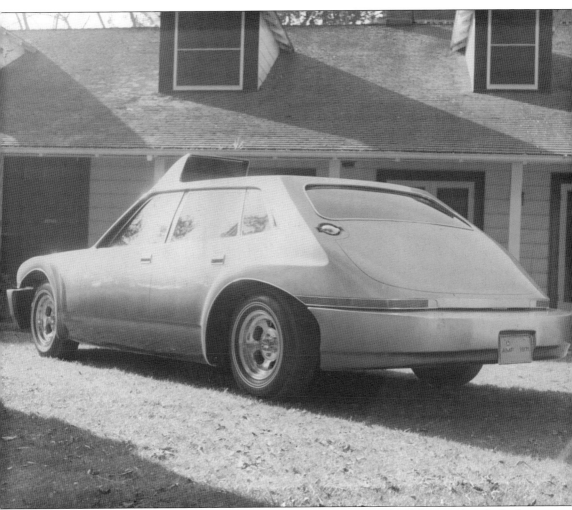

By the mid-1960s, Sam was going back and forth between Arizona and California, where he had a business modifying Camaros, and then worked for a while at Minicar in Goleta, which specialized in prototypes and mock-ups. Seen here is a full-sized mock-up, constructed of plywood and foam, displaying safety features that the Department of Transportation would soon make mandatory in American cars. (Courtesy of Sam Foose.)

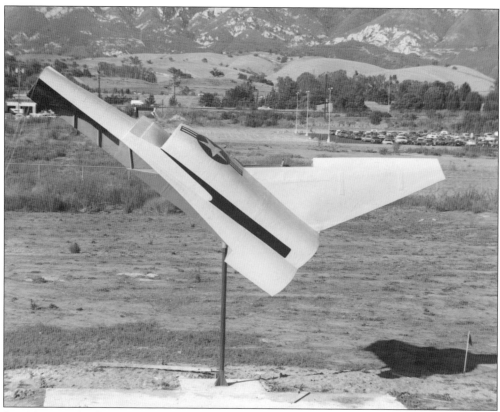

In 1969, Sam finally settled down in the northwest corner of Santa Barbara Airport, where he teamed up with fellow craftsman Ray Kinney to form a company called Project Design. Their main business was building prototype models for defense contractors. The image above is of an F-4E fighter jet front fuselage and wing leading edge mock-up, built for Raytheon Corporation as a radar test unit, and the image below shows a scale model of a massive cargo jet-zeppelin combination that was being presented to the Department of Defense. (Both, courtesy of Sam Foose.)

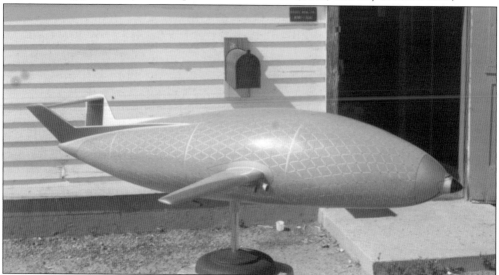

Project Design's other line of business was customizing and painting cars and boats. This freshly painted drag boat is parked in front of the Project Design shop, which also happened to be at the site of the country's first drag strip, operating there from the late 1940s to the early 1950s. (Courtesy of Sam Foose.)

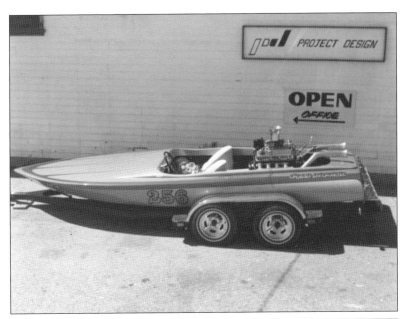

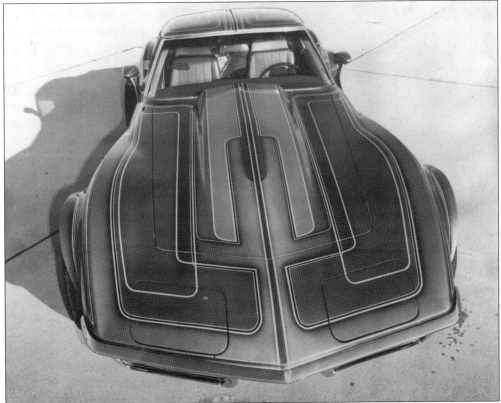

By the early 1970s, Sam's mastery at designing and applying custom paint jobs came to the fore. With their complex changes of tint and color density, mostly in metallic Kandy colors, and with bold design features, Sam's designs had to be seen in the daylight or under a streetlamp to be really appreciated. (Courtesy of Sam Foose.)

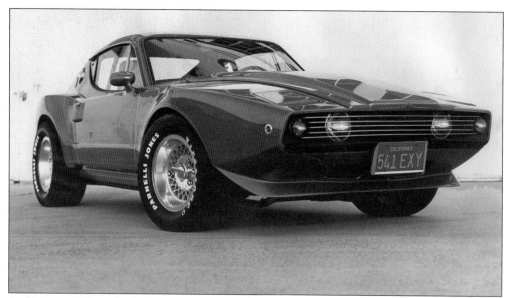

Saab's Sonett III was built from 1970 to 1974, primarily for the American market. The little two-seat coupe had rather sluggish performance, combined with poor reviews in the American press, particularly about its appearance, and it never sold well. Sam took this 1970 model and, with a little custom paint and bodywork, made it look quite attractive. (Courtesy of Sam Foose.)

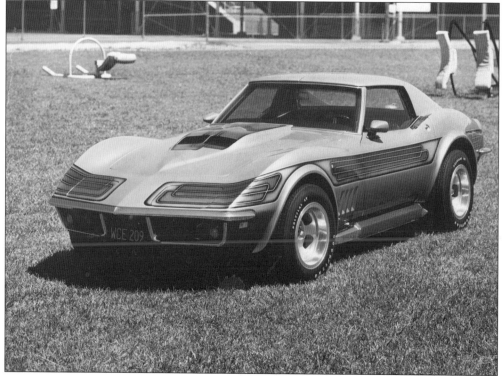

Sam's paint schemes inspired many of the Big Three auto companies' stylists with their innovative designs. This early C3 Corvette features a Kandy base color with accent panels in a complimentary color, enhanced with stenciled pinstripes. (Courtesy of Sam Foose.)

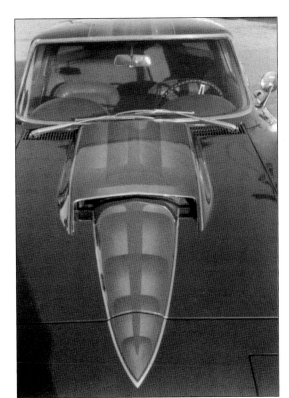

Variations on a theme: Sam's mastery with an airbrush is illustrated here with two different treatments of the 1967 Corvette hood. At right, the Art Deco–inspired design, rendered in copper and bronze tones, carries over to the roof of the car, while green swirling lines within panels framed in gold form an almost tortoise-shell effect below. (Both, courtesy of Sam Foose.)

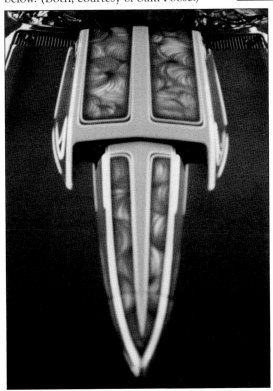

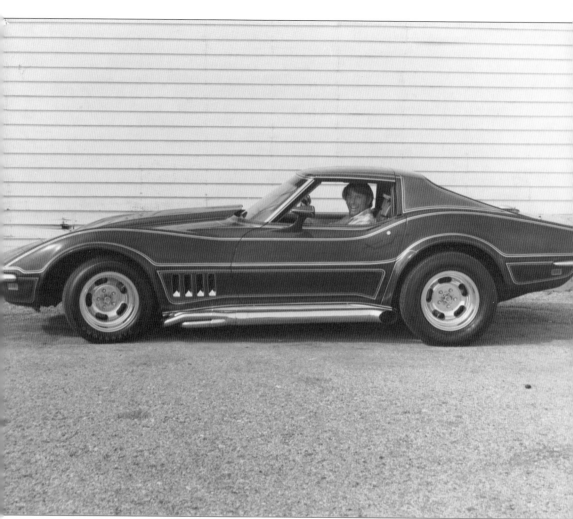

Sam's work was featured in national magazines like *Car Craft* and *Rod and Custom* from the 1950s until 2014, when he finally retired for health reasons. Seen here in the 1970s, happily behind the wheel of a beautifully finished Corvette, Sam now lives in Arizona, but he is still a revered member of the Central Coast hot rod community. His son Chip Foose is an internationally famous automotive designer who also has had several successful car-related television shows and is well known for his many charitable activities. (Courtesy of Sam Foose.)

Two

LOMPOC AND THE
MODEL T CLUB

In Lompoc during the Great Depression of the 1930s, as with the rest of the country, money was scarce and jobs were few. There was little for the young men of the area to do except hang out at places like the A&W root beer stand and drink 10¢ sodas—that is, if they had a dime. A group got together one fall evening in the basement of the Elite Bakery on South H Street and decided to break the monotony by staging a cross-country race using the venerable Ford Model T and inviting the public to watch. Gaining in popularity from year to year, the race changed from cross-country to oval track racing after the first few years. (Courtesy of Walter Schuyler.)

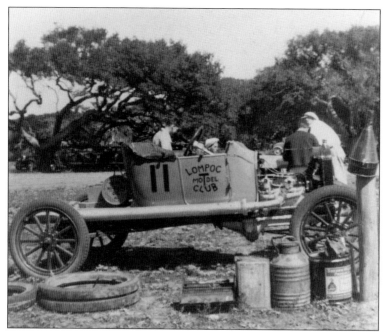

By 1936, the once ubiquitous Ford Model T was totally obsolete, and used examples could be had for practically nothing. Easily stripped down and simple to maintain, the Model T was a natural choice for low-cost motor sports during the Depression. This appears to be Armaund Cazenave and Walter Manfrina's "Shell Special," winner of the first race. (Courtesy of Walter Schuyler.)

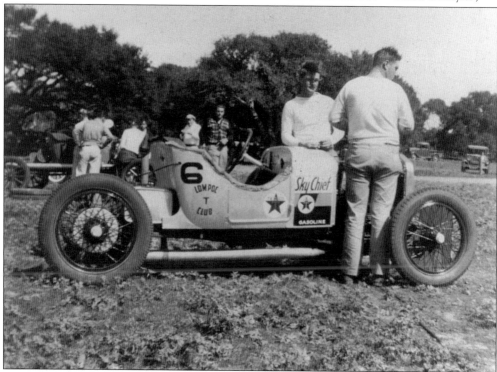

This racer is seen at the staging area near the starting line at Pine Avenue and H Street. Cars left at intervals from there, went roughly northwest over what is now Vandenberg Air Force Base to the beach at Lompoc Landing, then headed south to the village of Surf, east on Ocean Avenue, over LaSalle Canyon, and back into town via San Miguelito Canyon Road, a trip of over 35 miles. (Courtesy of Walter Schuyler.)

This is a good example of the type of car that competed in the early races. Although stripped down to the bare essentials, it is made up of unmodified stock parts. Later races had both stock and modified classes. Appropriately sponsored by Fred's Fix-It Shop, the car sports wooden artillery wheels and painted-on whitewall tires. (Courtesy of Walter Schuyler.)

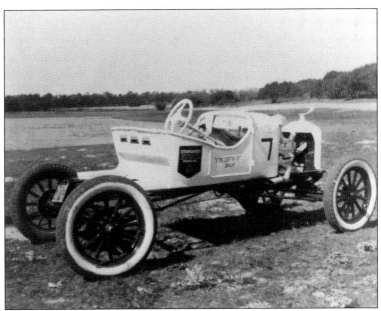

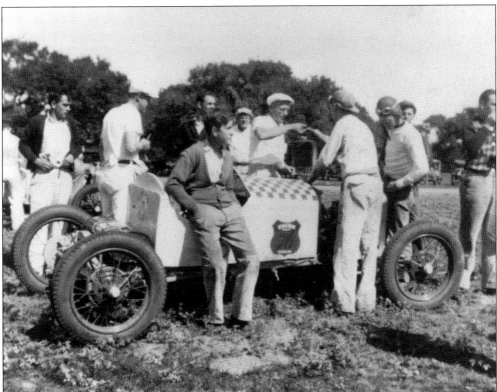

The rough cross-country course was hard on the old Model Ts, and most drivers traveled with a mechanic to handle the inevitable breakdowns as the cars were literally shaken apart during what was mostly an off-road race. Fortunately, the gas stations and garages of Lompoc employed quite a few talented Model T mechanics, and most of them were members of the club. (Courtesy of Walter Schuyler.)

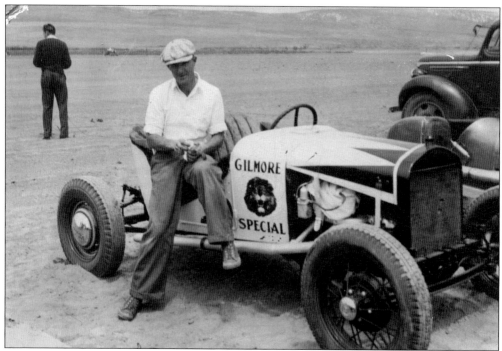

A relaxed Walter "Skip" Schuyler poses with his "Gilmore Special" at the Campbell Ranch as the Santa Ynez Valley stretches out behind him in this image from the late 1930s. Mimicking the paint scheme of the famous Gilmore racers of the period, Schuyler's machine was sponsored by the local Gilmore gas station. (Courtesy of Walter Schuyler.)

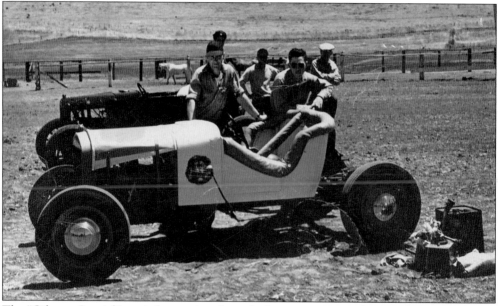

The "Gilmore Special" carried on racing through the postwar era and is seen here at the rodeo ground track sometime in the late 1940s. The name is no longer visible on the cowling, but it has kept the Gilmore lion decal on the sides. Note the toolbox, gas can, and other racing paraphernalia on the ground at lower right. (Courtesy of Walter Schuyler.)

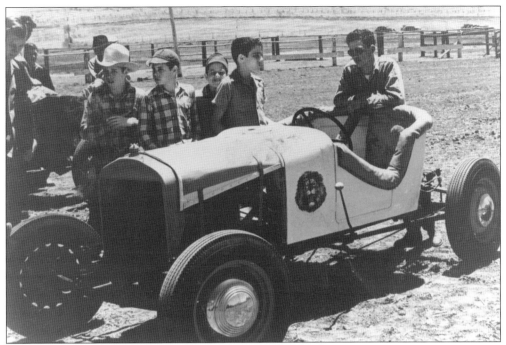

Model T racing was a popular attraction with Lompoc's younger set, too. This group of adolescent boys is seen inspecting Skip Schuyler's racer. One of Schuyler's mechanics, Don Kalin, is at right, making sure the boys keep their hands off. (Courtesy of Walter Schuyler.)

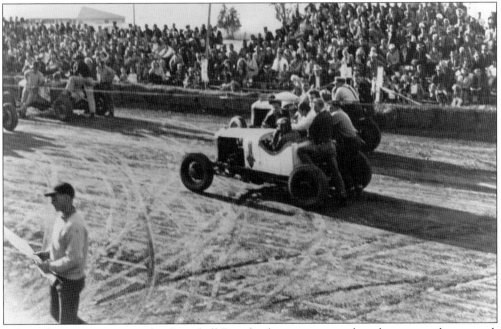

After a few years racing at the Campbell Ranch, the action moved to the town rodeo ground, located on the mesa off Seventh Street above Ocean Avenue on the east end of Lompoc. The races were a popular attraction, with three to four thousand people in the grandstands during a meet. Flagman Joe Avila is seen walking into the corner at lower left. (Courtesy of Walter Schuyler.)

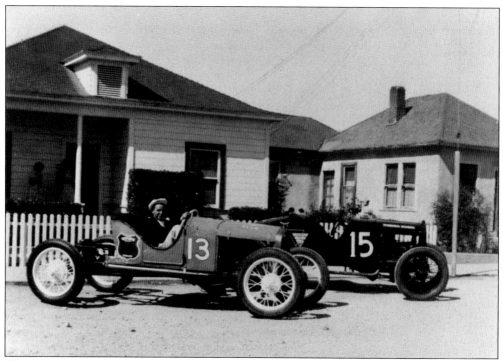

This sharp-looking pair of Model Ts was probably used more for cruising around the streets of Lompoc than for racing. Both cars display large gas pump decals, most likely taken from the gas station the cars' owners worked at. The one in front is for the Union Oil Company, and in back is Seaside Oil. (Courtesy of Walter Schuyler.)

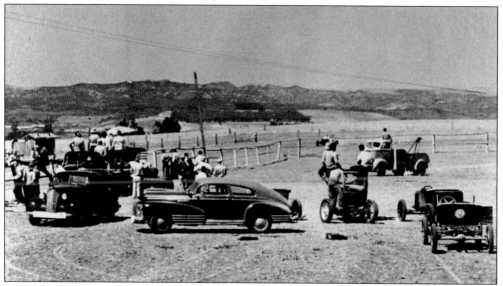

This shot, taken at the rodeo ground's infield pit area during the late 1940s, shows an interesting variety of vehicles. At far left, Lee Hammock's 1937 Chevy sits in front of a farm truck. Next, from left to right, are a Chevrolet Fleetline Aerosedan, a modified-class Model T, and a few stock-class racers; in the background is a cab-over-engine tow truck of unidentified make. (Courtesy of Walter Schuyler.)

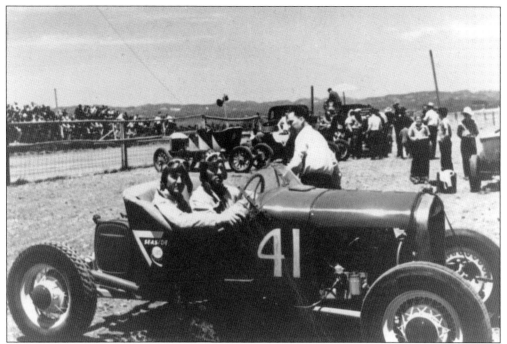

Tilton Brughelli (right) and his longtime mechanic Joe Costa (left) are seen in Brughelli's modified Model T. A Lompoc rancher and dairyman, Tilton had a reputation for being one of the best drivers in the Model T Club. (Courtesy of Walter Schuyler.)

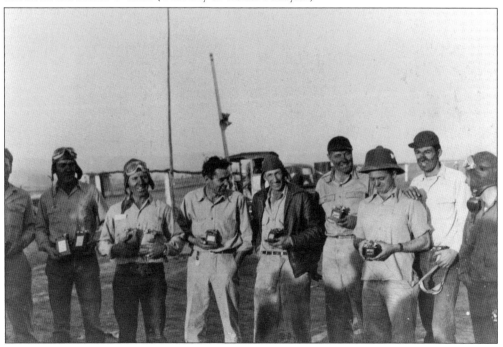

The trophies may be small but the grins are big in this group of winners. From left to right are unidentified, Joe Rios, Tilton Brughelli, Joe Costa, Bill McLaughlin, Chris Christiansen, Armaund Cazenave, Tony Machado, and unidentified. (Courtesy of Walter Schuyler.)

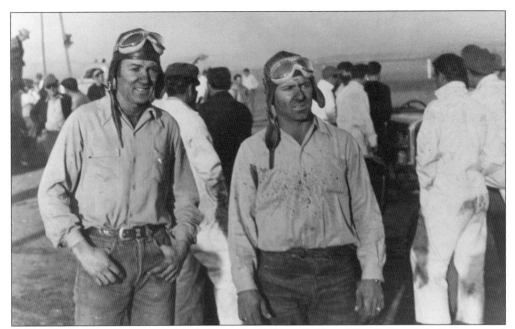

Although their faces are covered with dirt and oil, Costa (left) and Brughelli still look pretty cool in this image taken after a race. Joe Costa was a mechanic who worked at several garages and car dealerships in Lompoc throughout the years. (Courtesy of Walter Schuyler.)

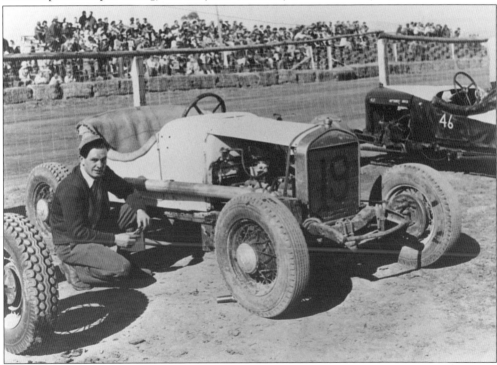

Johnny Grossini, one of a large local ranching family, is seen kneeling next to his modified Model T. It looks like he has mounted the Model T body and engine onto a Model A frame. Note the packed grandstands in the background. (Courtesy of Walter Schuyler.)

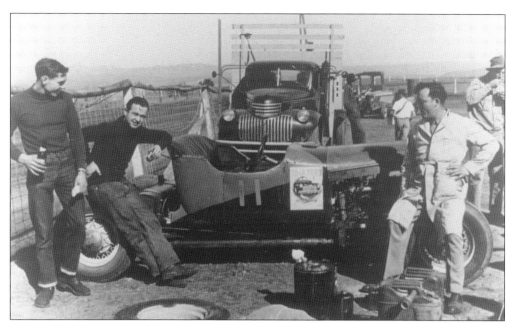

Seen taking a lunch break is the racing team of George Thayer (left) and Paul Thompson (right of Thayer, seated on tire). Jim Reynolds, a mechanic at the local Ford dealership, Beattie Motors, leans on the front tire at right. (Courtesy of Walter Schuyler.)

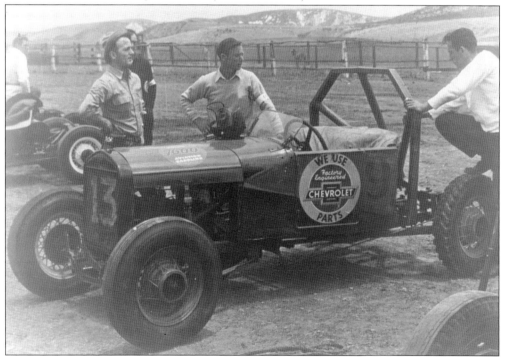

The rodeo ground at Lompoc was a true country racetrack, as can be seen by the livestock grazing in the center background. Armaund Cazenave (left) and Ike Henning (center) look off to the camera's right, while an unidentified individual at right tests the strength of the stocker Model T's very substantial roll bar. (Courtesy of Walter Schuyler.)

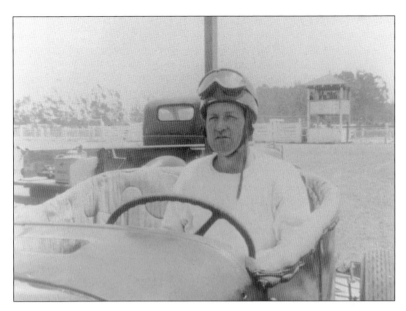

One of the more colorful drivers on the Lompoc scene was garage owner and engine builder Buck Riley. Married five times, he wore the wedding rings of each of his ex-wives on a string around his neck for luck. Note the quilted sleeping bag material used as a liner for the body tub. (Courtesy of Walter Schuyler.)

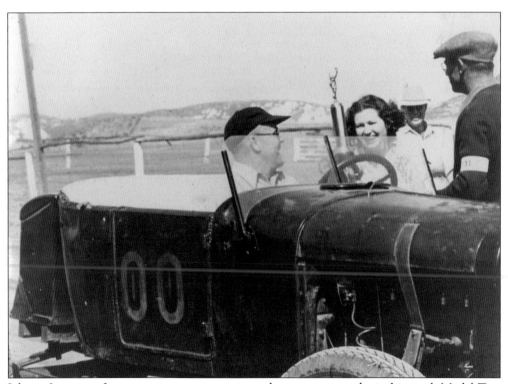

Johnny Janssen, a Lompoc tavern owner, grins as he accepts a trophy in his stock Model T as the still undeveloped Santa Ynez Valley stretches away in the background. The rodeo ground, like many of the old racetracks, would soon be covered by housing as the local real estate market expanded. (Courtesy of Walter Schuyler.)

Cousins Joe (left) and Tony (center) Machado glance furtively at the camera as an unidentified club official at right inspects their stock-class Model T. The car in the right corner background appears to be a 1941 Oldsmobile coupe. (Courtesy of Walter Schuyler.)

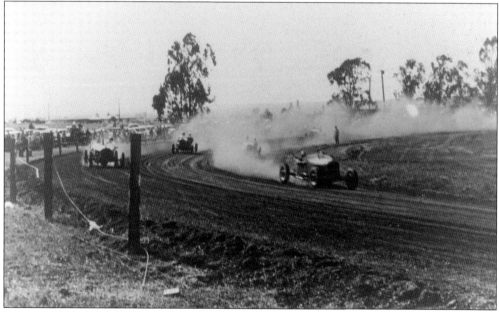

A group of Model Ts kicks up rooster-tails of dirt and oily exhaust as the cars race around the turn at the rodeo ground racetrack in this scene from the late 1940s. Model T racing at Lompoc would soon be replaced by the faster and more exciting sport of jalopy racing that was gaining in popularity on the California coast. (Courtesy of Walter Schuyler.)

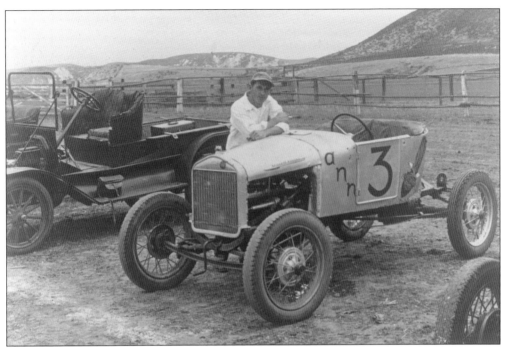

Lompoc Model T Club meets of the late 1940s attracted all types of Model T–based contraptions, as can be seen in the left background. Unfortunately, the person posing with the well-turned-out No. 3 "Ann" has not been identified. (Courtesy of Walter Schuyler.)

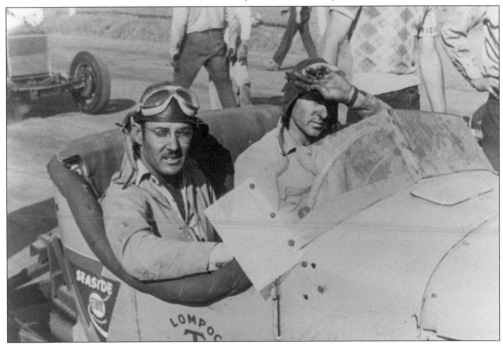

An exhausted Tilton Brughelli (left) and Joe Costa are seen here after finishing a grueling race at the Lompoc rodeo ground. The Model T they are seated in has been preserved and is in possession of the Lompoc Historical Society. (Courtesy of Walter Schuyler.)

Two charter members of the Lompoc Model T Club, Ike Henning (left) and Armaund Cazenave, pose with Henning's stock-class No. 13. Henning is wearing a 1930s-vintage blue Lompoc Model T Club cardigan complete with club patch. (Courtesy of Walter Schuyler.)

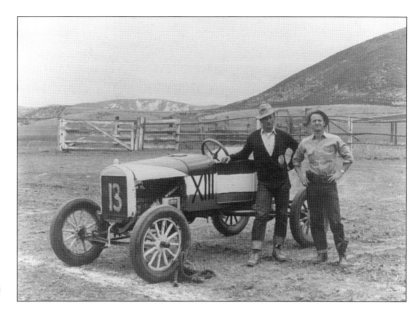

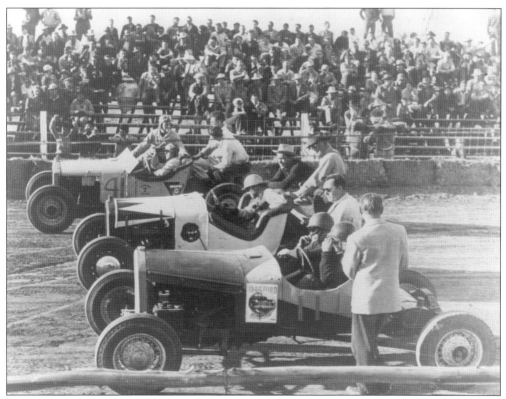

In this shot taken at the rodeo ground, three cars wait for the race to begin. In No. 41 (back) are Tilton Brughelli and Joe Rios, in the center is Skip Schuyler, and in the foreground is the team of Paul Thompson and George Thayer. (Courtesy of Walter Schuyler.)

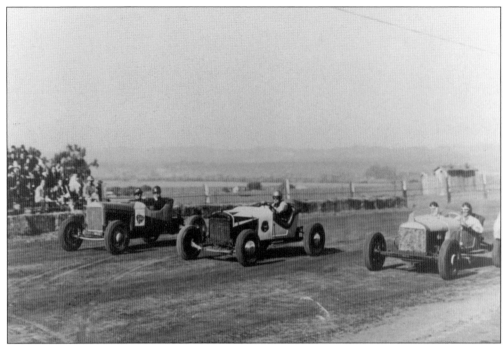

The cars are seen racing three abreast around the track in this view looking roughly northeast. The open spaces visible in the background and the track itself would be covered with houses as Lompoc's population grew in the coming decades. (Courtesy of Walter Schuyler.)

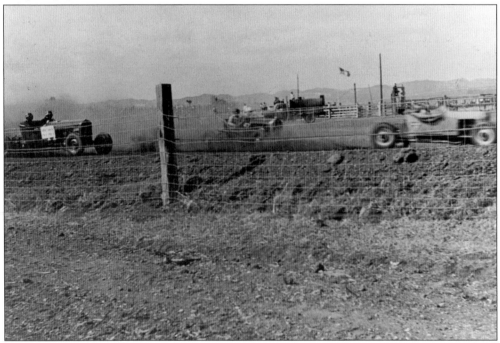

Here, a pack of Model Ts passes by the camera. The hog-wire-and-railroad-tie fence visible in the foreground was effective in containing the livestock during a rodeo but was not a good barrier for race cars and could be quite dangerous, as events would demonstrate. (Courtesy of Walter Schuyler.)

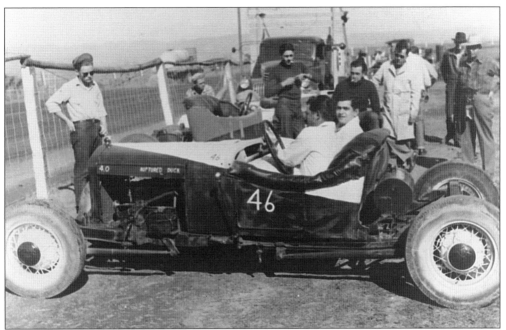

Johnny Grossini warms up his car, the "Ruptured Duck," with an unidentified mechanic as others look on. Standing in the middle background are George Thayer (left), Paul Thompson (center), and Jim Reynolds. All three worked as mechanics at Lompoc car dealerships. (Courtesy of Walter Schuyler.)

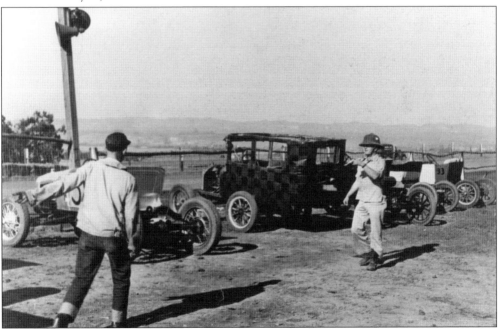

The odd-looking Model T in the center of this image is the club's clown car, "Leaping Lena." Painted in green-and-black checks and with offset wheel hubs, wheelie-bars, and an overhanging body, "Leaping Lena" provided comic halftime entertainment for the spectators. It is rumored to still be in existence and stored somewhere in Lompoc. (Courtesy of Walter Schuyler.)

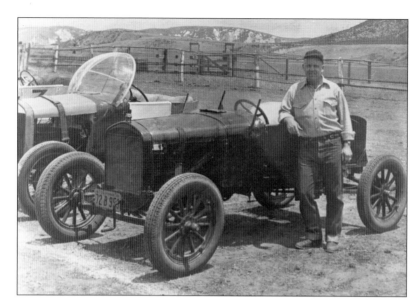

A casual Buck Riley smiles as he poses with his stock-class Model T. Note the car in the background. It looks like the owner has taken a war-surplus Plexiglas astrodome from a B-17 bomber and adapted it to serve as a windshield for his racer. (Courtesy of Walter Schuyler.)

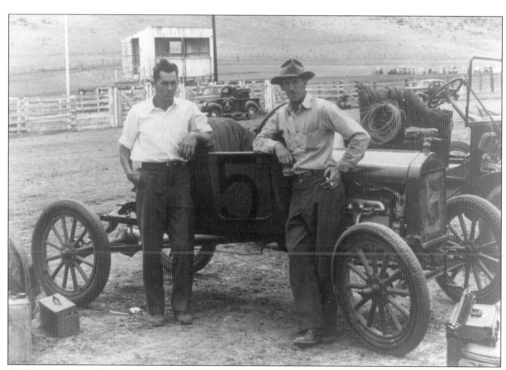

In this image, a dour Bob Howard (left) and Bill "Bronc" McLaughlin look at the camera. McLaughlin (who worked as a tractor operator for the county) would become the only fatality in the history of the Model T races in an event that would lead to the end of racing in Lompoc. (Courtesy of Walter Schuyler.)

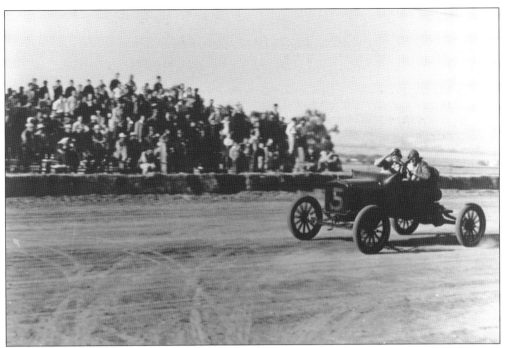

McLaughlin, in the driver's seat, and Howard are seen passing the grandstand. Rounding the curve and obscured by dust, another driver locked wheels with McLaughlin's car and sent it into a cartwheel. Not wearing a helmet and unprotected by a roll bar or seatbelts, Bronc's head struck a fence post, killing him instantly. (Courtesy of Walter Schuyler.)

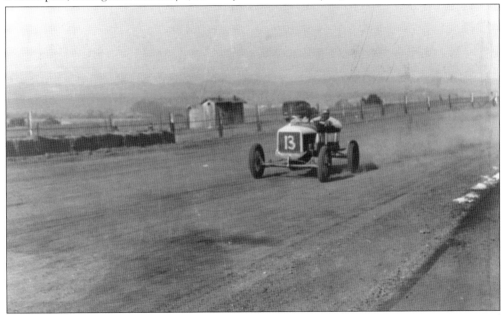

Veteran racer Ike Henning propels his fragile-looking Model T along the dusty rodeo ground track. By the late 1940s, parts for the Model T were not as easy to find as they had been 10 years earlier. A vast number of Ts were scrapped during the war, eliminating them as a parts source, and few replacement parts were still being manufactured. (Courtesy of Walter Schuyler.)

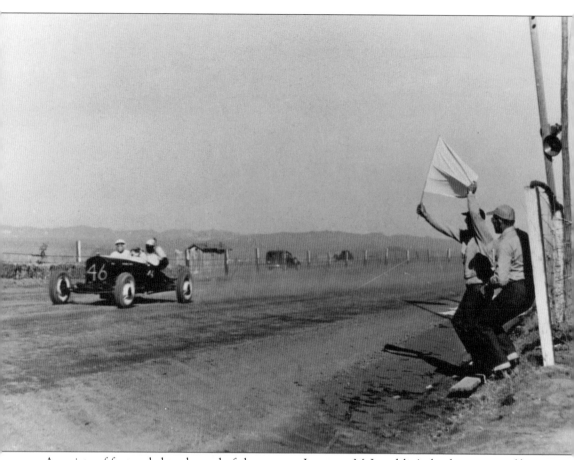

A variety of factors led to the end of the races at Lompoc. McLaughlin's death, a string of less serious accidents, and parts availability for the cars were some of the reasons. Two of the biggest factors were the rise of jalopy racing and the opening of a new track 15 miles east in Buellton. Here, Johnny Grossini passes flagman Tony Avila. (Courtesy of Walter Schuyler.)

Three

DON EDWARDS AND GOLDEN KOMOTION

Of all the drag boat aficionados who live on the Central Coast, few have done more for the sport than Santa Barbara native Don Edwards, seen here. The national championship winner is most famous for piloting his big, Hemi-powered hydroplane *Golden Komotion* to four Top Eliminator titles between 1965 and 1967. A graduate of Santa Barbara High School (class of 1957), Don began tinkering with small gasoline engines at an early age, graduating to motorcycles and eventually racing a hopped-up 1940 Ford coupe at the Santa Maria drag strip by age 16. Seeing a small race boat for sale at the Santa Barbara Yacht Club one day, Don fell in love and sold the Ford to buy it. Thus began a long and successful career in drag boats. (Courtesy of Don Edwards.)

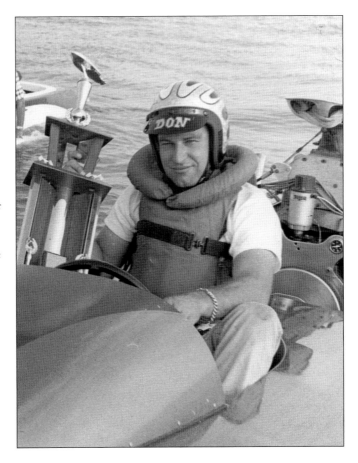

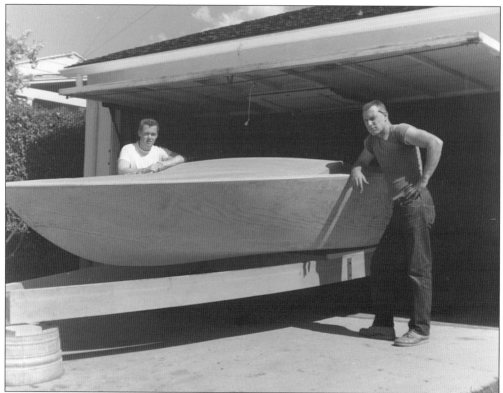

Don quickly outgrew his first boat and began looking for something else. He partnered with his cousin Bill Brinks (left) and purchased an unfinished wood hull built by Don Beck, an employee of Ambrose Lumber of Santa Barbara who built speedboat hulls on the side. Edwards is standing at right. (Courtesy of Don Edwards.)

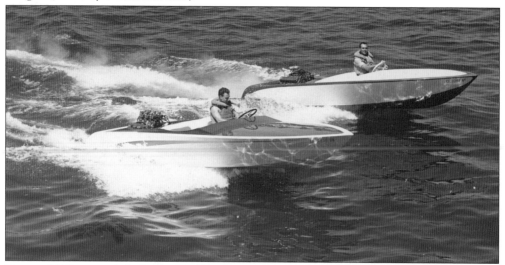

Don and Bill covered the hull with fiberglass and painted it white with a broad golden stripe. Power came from a 354-cubic-inch Chrysler Hemi built by Bob Joehnck, connected to a single propeller. Piloting the boat on the right is Santa Barbara High School automotive shop teacher Lloyd Corliss. His hull was also by Beck. (Courtesy of Don Edwards.)

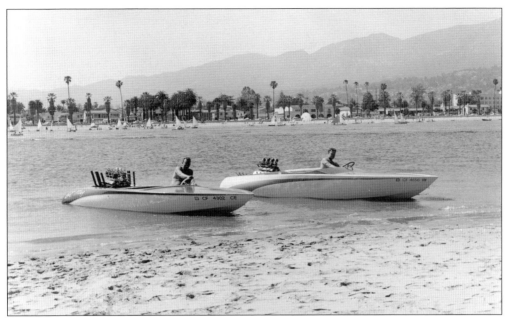

Don poses with another Beck hull, this time owned by Dick Dickman of Santa Barbara. The scene is the sandbar at the mouth of Santa Barbara Harbor. West Beach is visible in the background, with the marina to the left and Stearns Wharf off-camera to the right. (Courtesy of Don Edwards.)

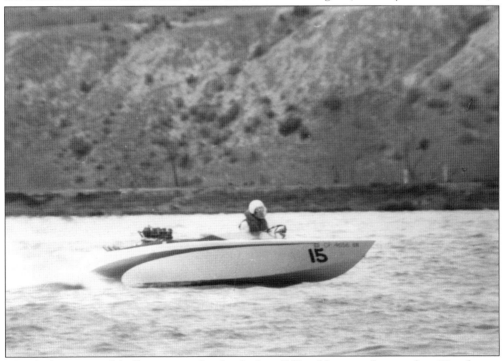

The flat-bottom Beck hull was pretty fast for the late 1950s, able to reach more than 80 miles per hour. Seen here in competition at Lake Ming, Don's gold-and-white boat was known for causing a commotion at races. People began calling it the *Golden Komotion*, and the name stuck. (Courtesy of Don Edwards.)

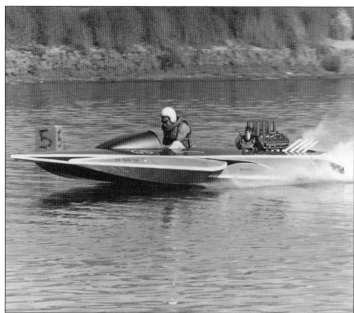

Don yearned for something faster and soon moved up to this 21-foot wooden hydroplane. Designed and built by Rich Hallett, the hull shows the pointed bow and runabout-style transom typical of Hallett's designs. The 450-cubic-inch Chrysler Hemi was built by Dave Zeuschel and is seen here in its original fuel-injected configuration. (Courtesy of Don Edwards.)

Here is an image of the 450-cubic-inch big-block Chrysler Hemi after installation of a GMC 6-71 blower unit. When he chose Zeuschel for the engine and Hallett for the hull, Don Edwards combined two of the very best talents in drag boat racing and got winning results. (Courtesy of Don Edwards.)

This view from the pits shows Edwards (second from left) making a last-minute adjustment while the master himself, Dave Zeuschel (center, plaid shirt), gives advice. Zeuschel would go on from building engines for cars and boats into the world of high-performance racing aircraft. He was tragically killed in a 1987 crash while piloting a jet airplane at an air show. (Courtesy of Don Edwards.)

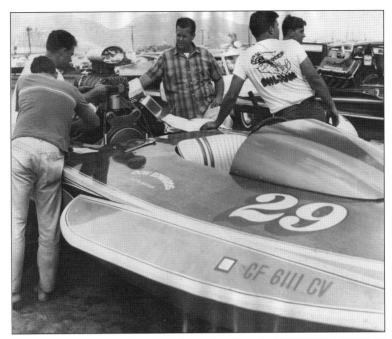

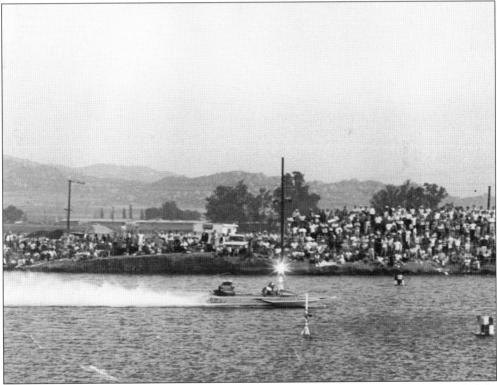

Golden Komotion speeds past the timing light in this shot taken at Ski-Land, a man-made lake near Perris, California. The hockey stick–shaped lake was specially designed for high-speed boating and became the site of National Drag Boat Association (NDBA) racing for six years starting in 1964. Races were also held at Lake Ming in Kern County. (Courtesy of Don Edwards.)

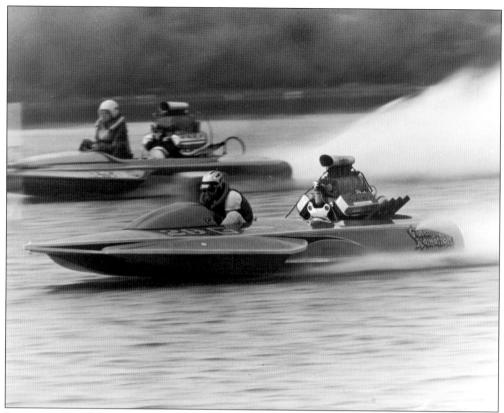

Don campaigned the *Golden Komotion* successfully for several years, setting the NDBA record for the blown gas class at 136 miles per hour in 1966 and taking the Winningest Gas Hydro trophy in 1967. Don wanted something bigger and faster and decided it was time to move up to the big boats of the unlimited hydroplane class. (Courtesy of Don Edwards.)

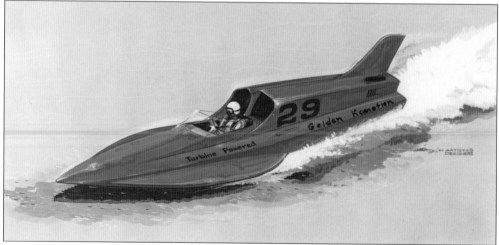

Don retired from drag boat racing and began to plan his next project. Rich Hallett was again chosen for the boat's design. Hallett was responsible for Lee Taylor's record-setting jet-powered *Hustler* and came up with a similar design for Edwards, seen here in an artist's conception. (Courtesy of Don Edwards.)

The all-aluminum boat was to be larger than the *Hustler*, with a wider transom, and would be propeller driven. Hallet used Dural aluminum for strength to construct the hull, which measured 30 feet, two inches, and had an 11-foot beam. The front and profile images here display the fine craftsmanship that went into the boat's construction. Completely fabricated by Hallet, the hull followed the *Hustler*'s driver-forward cab-over design but was larger and stronger. It had to be because the big unlimited hydroplane's hull was going to take quite a pounding with a projected speed of over 300 miles per hour. (Both, courtesy of Don Edwards.)

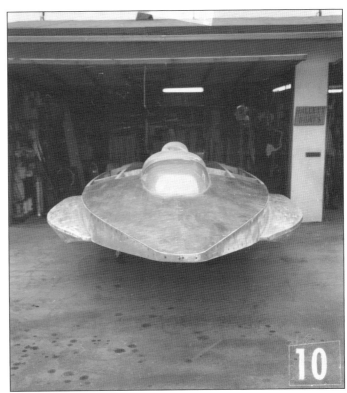

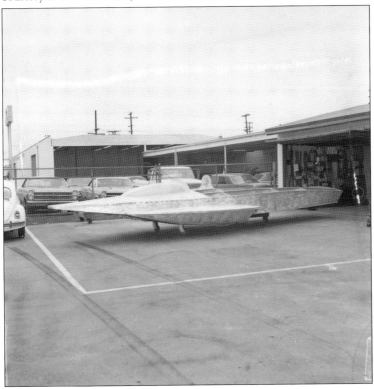

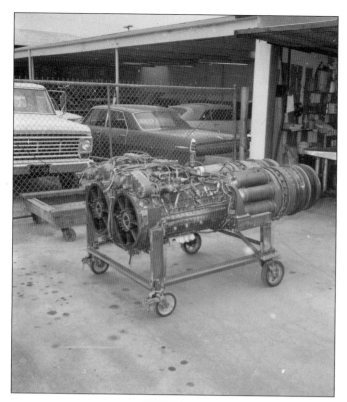

For an engine, Edwards and Hallet rejected the conventional auto or aircraft piston engines used in hydroplanes of the day and decided to go with turbine power, which no one had done before. Through a Los Angeles–based war surplus dealer, they were able to acquire an Allison T40 turboprop. The T40, developed in the late 1940s for use in military aircraft, combined two T38 power sections (left) mounted to a reduction gearbox (below) and had the potential to reach 5,000 horsepower. The complex and temperamental unit self-destructed on an early test run, and unable to source a suitable replacement, Edwards was forced to abandon the project. (Both, courtesy of Don Edwards.)

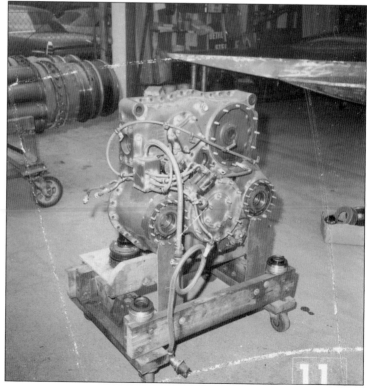

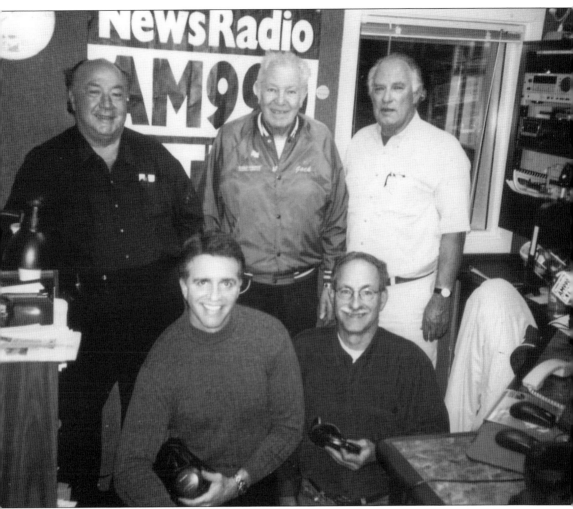

Although Don has retired from racing, he continues to support drag boating. He lives in Solvang, California, with his wife, Lydia, and makes frequent public appearances at events throughout the West. Don also owns a restored 18-foot, wood-hulled, Hemi-powered hydroplane that he displays at car and boat shows. He is seen here with two other luminaries of the motor sport world, Andy Granatelli (standing left) and Jack Mendenhall (standing center), after the taping of *Guy Talk*, a local radio show. *Guy Talk* host Steve Ford is sitting at left, and Roy Miller is at right. (Courtesy of Don Edwards.)

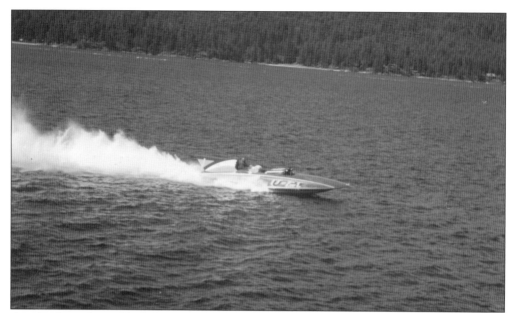

Another big unlimited hydroplane with a local connection worthy of mention was Lawrence "Bill" Schuyler's $ Bill, seen here. Schuyler was a Lompoc farmer who was heavily into the hydroplane racing scene during the late 1950s and 1960s, setting many records and winning races in a Wickens-built 266-class boat. (Courtesy of Chuck Bohl.)

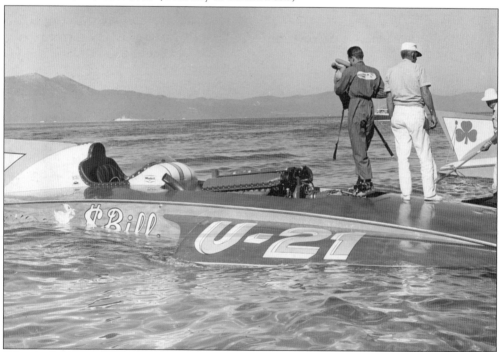

Schuyler had Fred Wickens build a larger version of the 266-class hull and christened it the $ Bill. Plagued with handling problems, the boat was quickly sold, and a new one, built by Les Staudbacher and pictured here, was much more successful. Schuyler campaigned the boat until 1967, when he retired from racing. (Courtesy of Chuck Bohl.)

Four

THE ROAD RACERS

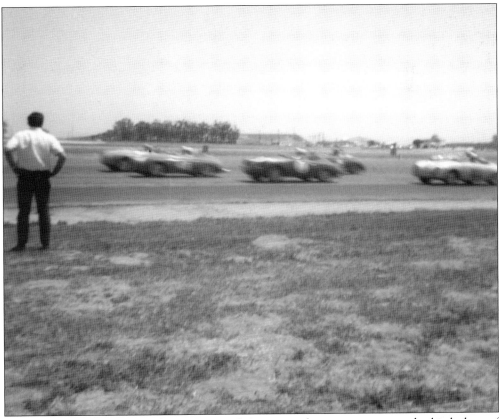

Goleta, site of the Santa Barbara Municipal Airport, is known to many as the birthplace of professional drag racing. The first legally sanctioned races in the country were held there in 1948 and continued until 1951. About the time the hot-rodders were moving on to other strips, a different group of car enthusiasts was moving in. Coming from a variety of backgrounds, they liked to race on a closed course, European-style, rather than in a straight line. Instead of drag racing, this was called road racing. The cars were different too. Taking advantage of a strong postwar dollar, local car buffs were able to purchase the best that European car manufacturers had to offer. And that usually meant sports cars. In this image from 1954, a pack of Porsche 356 Speedsters rounds Turn Six. (Courtesy of Lee Hammock.)

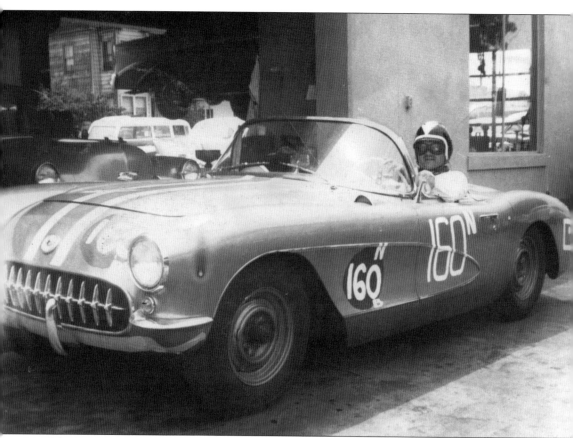

John Masterson, pictured here, is typical of the type of amateur-turned-semiprofessional racer that made up the road racing group. Originally from Portland, Oregon, his family moved to Longview, Washington, where his father was the local Chevrolet dealer. As a reward for both graduating high school and being accepted into Stanford University, John was given a snappy new red 1953 Chevrolet Bel Air convertible by his dad. This was soon swapped by his dad for a 1954 Corvette (not pictured), because Bel Airs were selling and Corvettes were not, and there was one on the lot that was not moving. (Courtesy of John Masterson.)

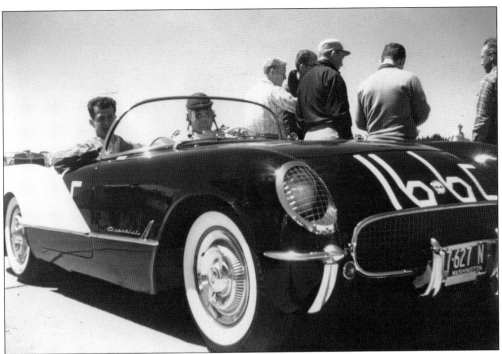

Although initially disappointed at the trade, John soon fell in love with the sporty Corvette. A visit to the road races in Carmel, California, in 1954 sparked John's interest, and by May 1955, John entered his first race at Cotati, near Santa Rosa, California. He is seen here on that day with his friend George Hemmiger (left). Note John's World War II surplus glider-pilot crash helmet. (Courtesy of John Masterson.)

John's Corvette is enveloped in a cloud of dust and exhaust as it comes around Turn Nine at Cotati. It was a typical 1954 model with the venerable 235 six-cylinder engine, tweaked by Chevrolet up to 150 horsepower, attached to a two-speed Powerglide automatic transmission. Although sluggish for a sports car, the Vette managed to finish in the middle of the pack. (Courtesy of John Masterson.)

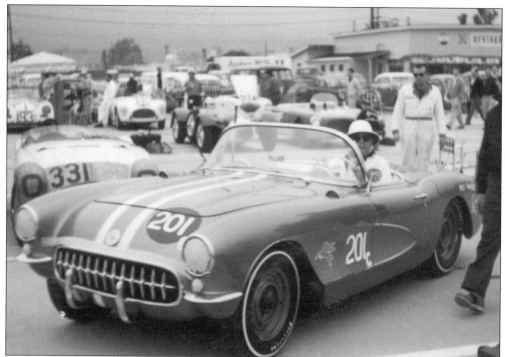

By 1955, John's family had moved to Santa Barbara, and after graduating from Stanford in 1957, he joined them. John had moved up to a new 1957 Corvette (pictured here) and began participating in the twice-yearly races held at Goleta by the California Sports Car Club and the Santa Barbara Jaycees. (Courtesy of John Masterson.)

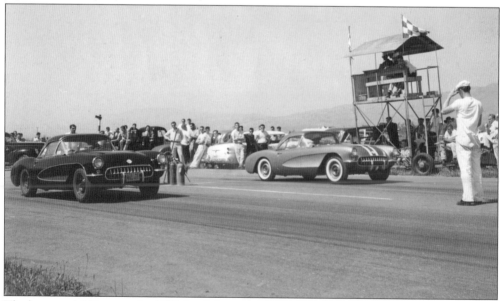

The base-model Corvette for 1957 that John owned (right) featured a single-carb 283-cubic-inch V-8 and a three-speed transmission. With options like fuel injection and a special heavy-duty racing suspension package, Corvettes could be purchased from the factory ready to race. (Courtesy of John Masterson.)

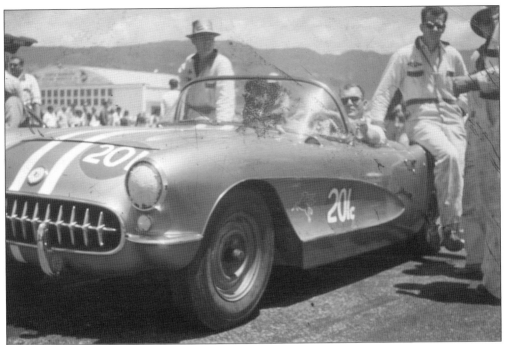

John is seen here waiting for his safety inspection at Goleta. With him are his frat brothers–turned–pit crew, George Hemmiger (leaning on car, right) and Tom Williamson (left). Race preparation amounted to removing the hubcaps and exhaust cut-offs and painting a racing number on the car. (Courtesy of John Masterson.)

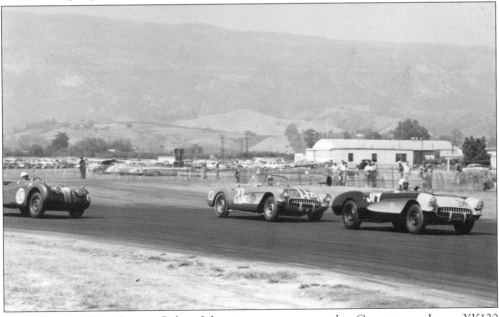

Coming around Turn Four at Goleta, John tries to get past another Corvette as a Jaguar XK120 brings up the rear. The first redesign of the Corvette really established the breed's reputation as a seriously competitive sports car. This image was taken with a view looking northeast, with the foothills of the Los Padres Mountains in the background. (Courtesy of John Masterson.)

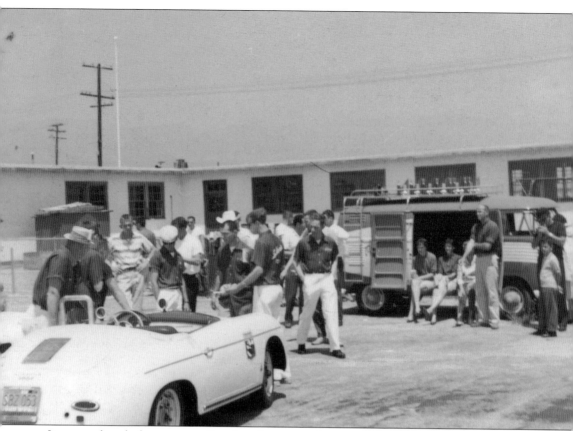

It was not long before a group of local road racing enthusiasts formed a car club, Scuderia Pacific. The name was taken from the famous Italian racing team Scuderia Ferrari, and the club was formed from several members of the Igniters car club plus a number of other like-minded individuals. Fielding a mixed bag of European sports cars (and a few V-8-powered specials), the club was a regular fixture at Goleta. This shot, taken in the early 1960s, shows club members in their distinctive blue sport shirts milling around the pit area at Goleta. (Courtesy of John Masterson.)

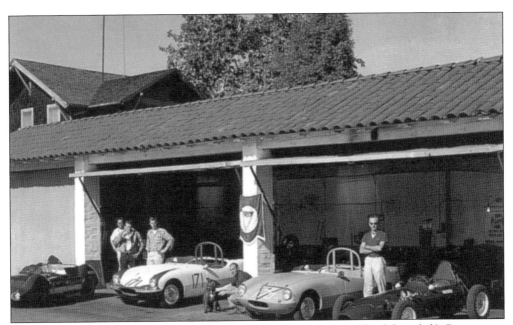

One of the prime motivators of Scuderia Pacific was Barry Atsatt (third from left). Barry ran a foreign car parts business located at the corner of De la Vina and Carrillo Streets in Santa Barbara called LeBaron Imports and was also a dealer for the British sports car make Elva. Standing at far right is Norm Babcock, salesman and serious racing enthusiast. (Courtesy of Barry Atsatt.)

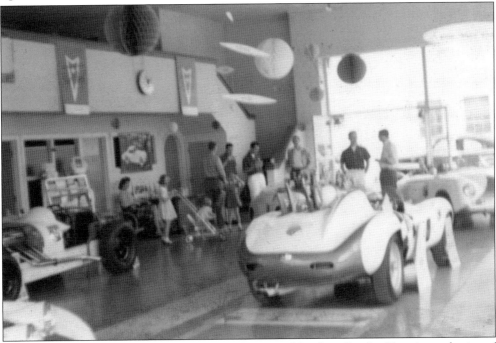

Like in most car clubs, social activities were a big part of Scuderia Pacific. Here is a gathering of club members at a local Oldsmobile dealer. In the foreground is a Ferrari 250 belonging to club member Dick Brashear. As an example of how dedicated some of these people were to the sport, Dick mortgaged his house to purchase the car so he could race. (Courtesy of John Masterson.)

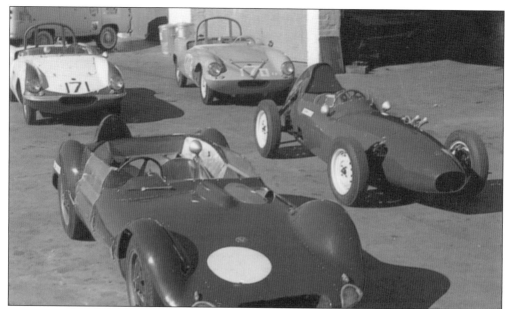

Elva sports cars were produced by British garage owner Frank Nichols, the name "Elva" coming from the French phrase *elle va*, meaning "she goes." In back are two Courier Mk 3 roadsters, Elva's main product, and in front are two dedicated racing machines, an Mk 5 (left) and Formula Junior (right). In the background is LeBaron Import's English Ford Thames delivery van. (Courtesy of Barry Atsatt.)

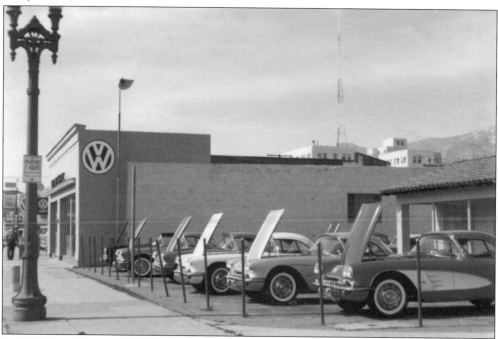

By 1958, John Masterson had joined Scuderia Pacific and also followed his dad into the car business by getting a job at Washburn Chevrolet in Santa Barbara. John took this shot of a line of new Corvettes in a variety of color schemes on the Chapala Street lot. At Van Wyk Volkswagen next door, business was just heating up. (Courtesy of John Masterson.)

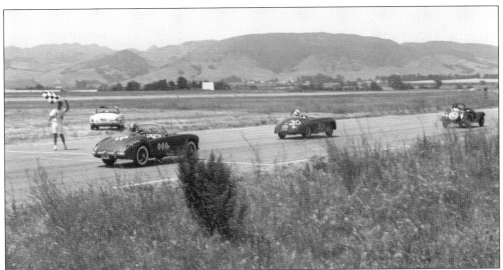

The airport at San Luis Obispo was a popular venue for both road racers and drag racers. In this shot, an MGTC leads a Porsche and John in a borrowed MGA past the checkered flag while a Mercedes 190 sits on the grass infield. (Courtesy of John Masterson.)

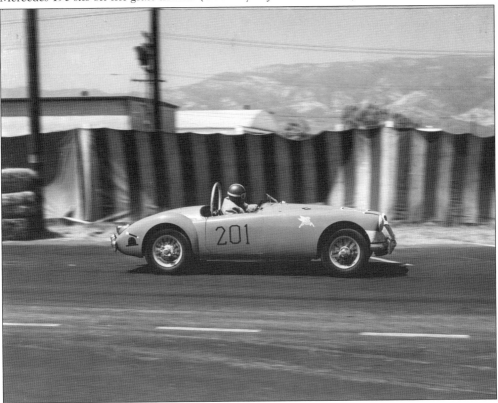

John convinced a customer that her new MGA needed some breaking in at the racetrack. With the application of a few decals and some tape on the headlights, he was ready to race. The hat and cane painted on the rear fender symbolized Bat Masterson, a Western lawman known for his classy attire. (Courtesy of John Masterson.)

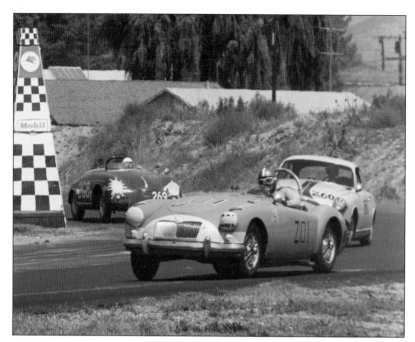

In this great action shot, John leads an Alfa and a Porsche around Turn Eight at Goleta. He had by then acquired the nickname "Bat Masterson" after the popular 1950s Western TV series of the same name starring Gene Barry. (Courtesy of John Masterson.)

One of the well-known drivers in the 1959 race season at Goleta was Ken Miles, seen here in his Porsche RS. His sponsor was Otto Zipper, a purveyor of German cars in Beverly Hills and an enthusiastic supporter of the road racing community. (Courtesy of John Masterson.)

The races at Goleta attracted the big guns from all over the West. John Edgar was a dealer in high-end sports cars to Hollywood's elite and traveled to the races in style. Living every racer's dream, Edgar fielded a Maserati 450 transported by a full-sized tractor-trailer. (Courtesy of John Masterson.)

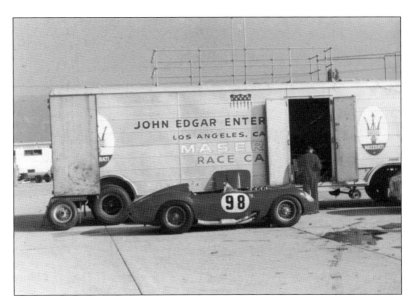

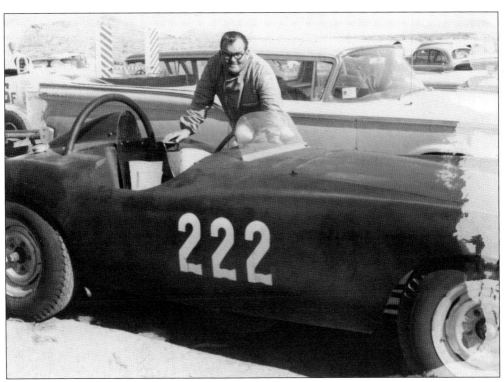

In 1959, John traded his Corvette to Reno-based veteran racer Merle Brennan for "Brennan's Beast," a notoriously ugly tube-framed open-wheel special. John stripped the "Beast" down to its frame, had Bob Joehnck build a Corvette engine and drivetrain, and covered it with a plastic body by Byers. The result is pictured here. (Courtesy of John Masterson.)

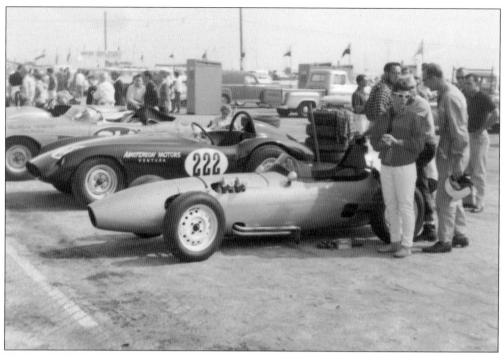

The "Batmobile," as it came to be known, soon became a fixture at race meets throughout the state. Here, it is seen in company with Barry Atsatt's MGA-powered Elva Formula Junior at Pomona Raceway in 1960. By this time, John had moved on to his own dealership, Masterson Motors of Ventura, selling Volkswagens. (Courtesy of John Masterson.)

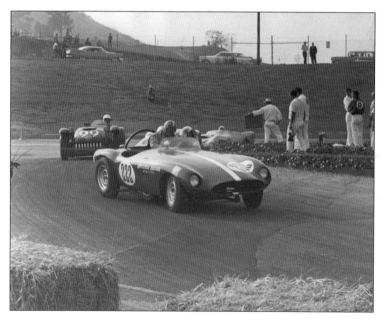

In this image from Pomona, John and the "Batmobile" lead Jerry McGee of Norwalk in his Corvette-powered Kurtis-Kraft. American-built kit cars like the Kurtis or specials like the "Batmobile" often dominated the Central Coast road racing scene. (Photograph by James W. LaTourette.)

John took home first place in the big-bore class in that meet and was rewarded with a kiss from Marianne Gaba, *Playboy* magazine's September 1959 Playmate of the Month. This shot was taken in front of Otto Zimmer's Volkswagen press van. (Courtesy of John Masterson.)

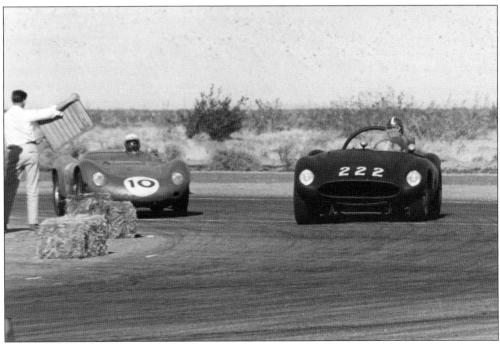

John leads Dick Hogue in his Porsche RSK (No. 10) around Turn Eight at Palm Springs during the 1960 season. The expensive aluminum-bodied Porsche R series was a common sight at racetracks all over the state. (Photograph by James W. LaTourette.)

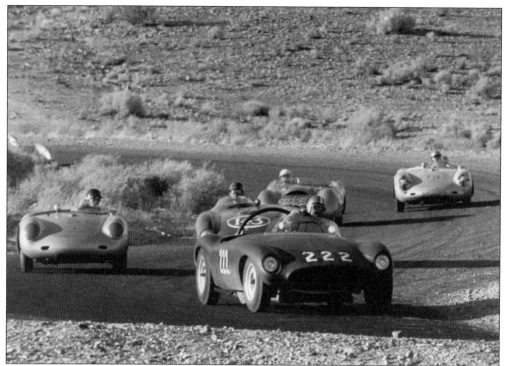

The racetrack at Willow Springs, in the Mojave Desert near Bakersfield, California, was another hot spot for road racing. In this shot, John Masterson leads a Ferrari Testarossa and a Porsche RSK, while in the back, John Timanus in his Lotus-Climax cuts off California Sports Car Club (CSCC) president D.D. Michelmore in his Porsche RSK. (Photograph by James W. LaTourette.)

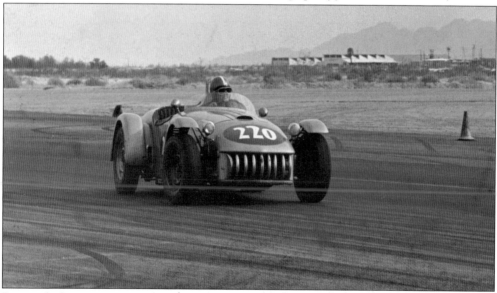

During the busy 1960 race season, John Masterson added this Corvette-powered Kurtis 500. Built from a kit by noted Santa Barbara race car creator Willis "Bill" Baldwin, it was sold to Masterson for $1,000. Baldwin thought the car and Masterson would be a good match, although front-engine road race cars were on their way out by then. (Photograph by James W. LaTourette.)

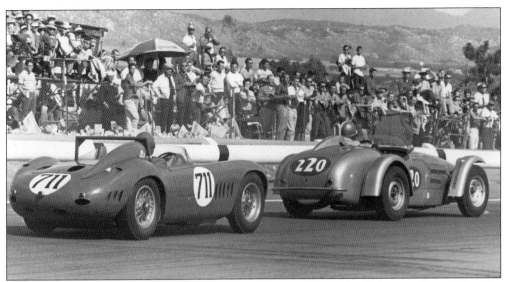

The big Kurtis could be a handful at racing speeds, even for a man of Masterson's size. Here, he manages to stay in front of a Maserati 300-S, driven by Bill Dixon of Canoga Park, California. This image was taken at the June 25, 1960, Sports Car Club of America (SCCA) meet at Pomona. (Photograph by James W. LaTourette.)

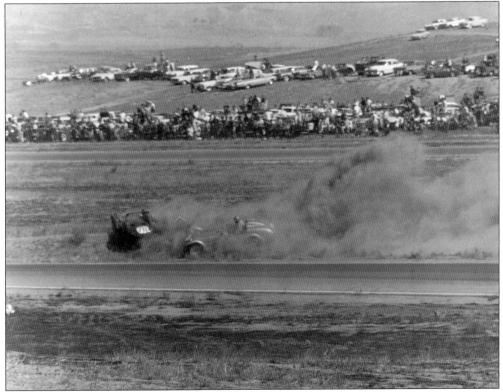

As a result of the duel depicted in the previous image, Masterson and Dixon wound up spinning into the infield in a cloud of dust. Note the crowds lining the return track opposite with little or no barrier between them and the action. (Photograph by James W. LaTourette.)

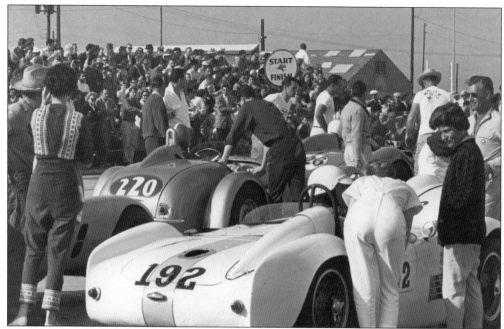

By 1960, the popularity of road racing in California was reaching its peak, with crowds of over 30,000 attending each of the two meets held at Goleta that season. In this scene taken at the starting queue, various mechanics and hangers-on mill about the line as the drivers sit expectantly in their mounts. (Photograph by James W. LaTourette.)

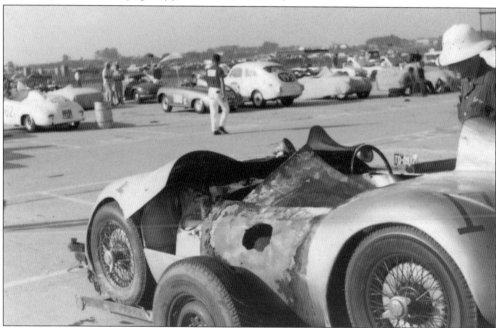

Road racing could be dangerous. This shot shows Scuderia Pacific member Dick Neal examining what appears to be the burned-out Campbell Special as it sits forlornly on its trailer. Well aware of the dangers of road racing, clubs began requiring safety equipment like fire-resistant suits and crash helmets early on. (Courtesy of John Masterson.)

Plastic- or fiberglass-bodied "specials" were the cheapest and easiest way to get into road racing. Scuderia Pacific member Don Holle is seen here in his MGA-powered special at Goleta. Note the wide variety of body styles visible among the other cars in this image. (Courtesy of John Masterson.)

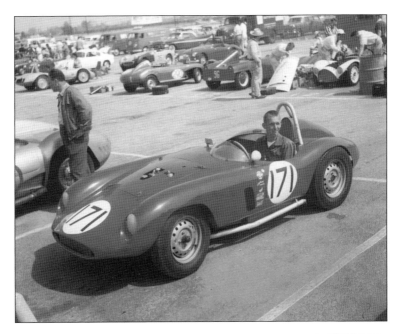

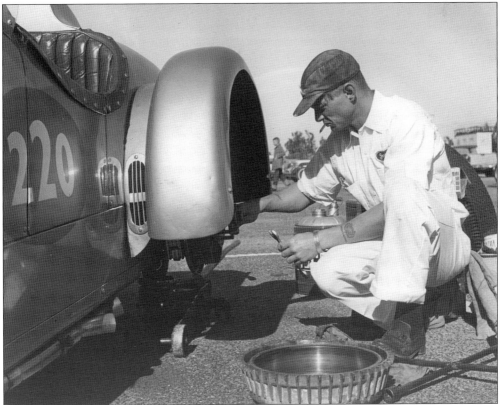

Although the cars and drivers attracted most of the public's attention, the skilled mechanics of the pit crews were an essential element in the world of motor sports. Jerry Beam, of John Masterson's crew, adjusts the big drum brakes on Masterson's Kurtis. (Photograph by James W. LaTourette.)

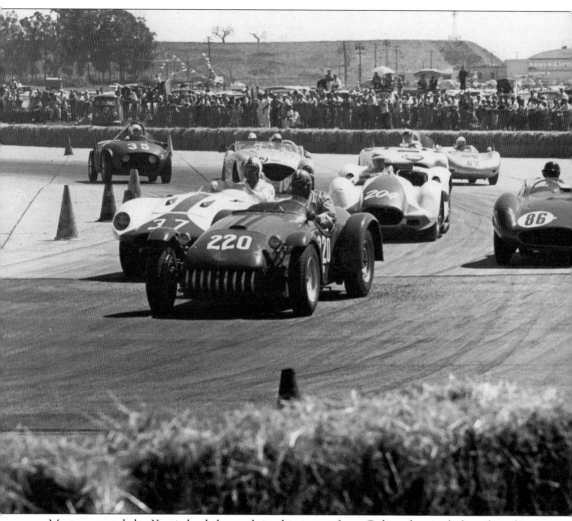

Masterson and the Kurtis lead the pack in this image from Goleta that includes a lot of very interesting cars. Visible are a Ferrari Testarossa (No. 86), a Devin Triumph (No. 37), a big Healey (No. 199), a Lister-Chevy (No. 204) and a Porsche RSK (No. 62). Left of the Porsche is what appears to be the Renault-powered Sondra Special (No. 146), and at the rear is another creation of Bill Baldwin, his third special (No. 35), now powered by an Oldsmobile engine in place of its original Ardun-Mercury. Finally, in the left background is the Volkswagen Samba press van belonging to Otto Zimmer. Zimmer was a Los Angeles–based Porsche and Volkswagen dealer and race enthusiast who equipped a van with typewriters, tape machines, a telephone, and other accoutrements and made it available for the local press to use at race events in the region. (Courtesy of John Masterson.)

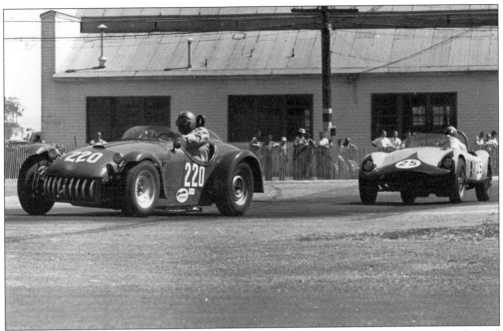

In this shot, it is a battle between two Chevrolet-powered specials. John Masterson in his red Corvette-engined Kurtis leads Jim Chaffee in his Devin-Healey-Chevrolet, the "Pink Elephant III" (No. 25). Chaffee's racer still exists today, albeit engineless and in somewhat battered condition. (Courtesy of John Masterson.)

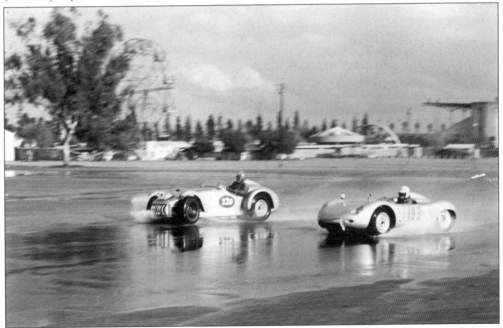

Masterson and Betty Shutes, in her Porsche RSK, try to avoid hydroplaning as they hit a wet patch on the track at Pomona. Shutes was a well-known personality on the West Coast racing scene. Besides being the press and publicity representative for the SCCA, she was also an active member of the Porsche Owners Club. (Photograph by James W. LaTourette.)

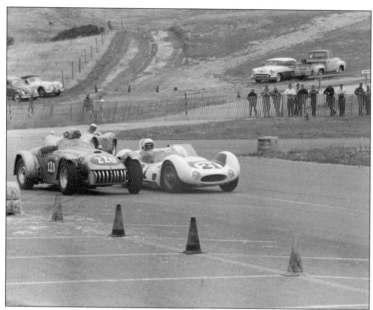

Turning onto the straightaway at Pomona, John, in the Kurtis, attempts to cut off a Maserati Type 61 Birdcage. Kurtis-Kraft was the manufacturer of a variety of racing and sports cars based in Glendale, California. Masterson's 500 was the most common model and could be purchased as a kit or fully assembled. (Photograph by James W. LaTourette.)

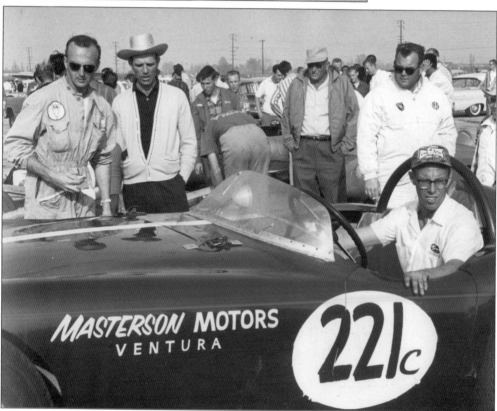

Norm Babcock (standing, far left) and John Masterson (white jacket and sunglasses, right) appear tense as they watch a member of the pit crew warm up the "Batmobile." Although both of John's cars were still competitive during the 1960 season, they were already obsolete. Rear-engine cars like Porsches and Cooper Climaxes were the future. (Photograph by James W. LaTourette.)

Scuderia Pacific and LeBaron Imports entered this Elva Courier with John Masterson and Norm Babcock as drivers in the 1960 meet at Sebring Racetrack in Florida. This image of the team's pit stall shows Norm making an adjustment to the car's engine. The team's Courier raced well, but fuel-line problems prevented it from reaching its full potential, and it placed 37th. (Courtesy of John Masterson.)

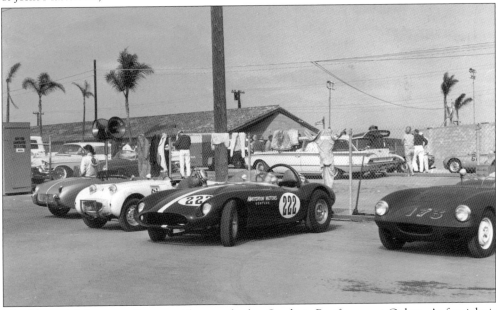

The "Batmobile" sits in a line up with several other Scuderia Pacific cars at Goleta. At far right is Bill Moore's Elva Courier, and at left are a pair of Austin-Healey Sprites owned by Jim Thompson (right) and Gary Meeker (left). Note the sweat-soaked racing suit hung out to dry on the fence in the background. (Photograph by James W. LaTourette.)

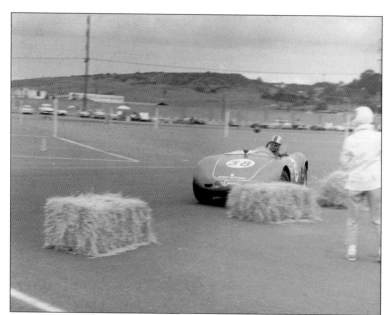

"Scooter" Patrick of Manhattan Beach, in the Porsche-powered Adam-Mitchell Special, is about to clip a hay bale in this image from the June 1960 meet at Pomona. Note the spectator standing perilously close to the action at right. (Photograph by James W. LaTourette.)

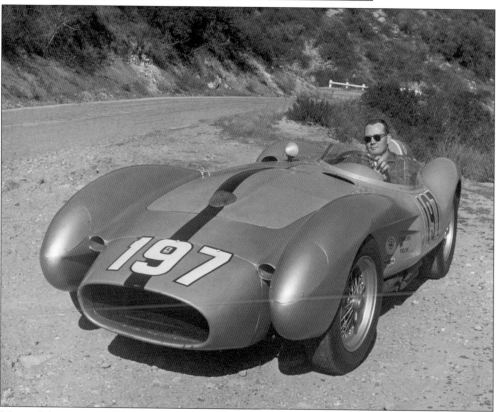

Most of the images in this chapter were shot by James W. LaTourette. LaTourette was an avid motor sports enthusiast who worked as a photographer at nearby Naval Air Station Point Mugu. He is seen here on the other side of the camera, posing on a back road in Dick Brashear's Ferrari Testarossa. (Courtesy of James W. LaTourette.)

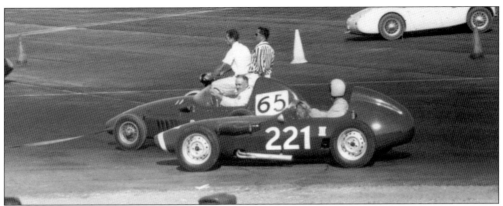

Formula Junior was an offshoot of Formula 1 grand prix racing and served as a relatively inexpensive way to practice the sport. Seen here in the Goleta staging area before a race are an Italian Stanguellini at left and a British Elva at right. (Courtesy of John Masterson.)

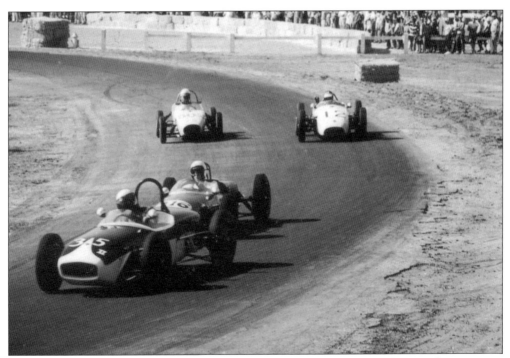

Formula racing has its roots in some of the earliest forms of motor sports, where single-seat, open-wheel cars competed on a closed course. In this shot, a Lotus 18 leads the pack during a race at Goleta in the early 1960s. (Courtesy of John Masterson.)

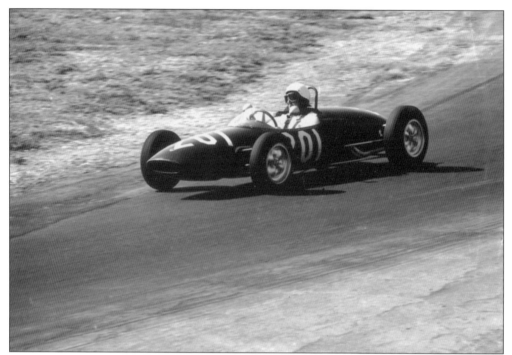

One of the most dominant names in Formula racing is the British marque Lotus. Besides being very successful on the track, Lotus race cars possessed a certain graceful beauty, as seen with this Lotus 20 Formula Junior at Goleta during the 1962 season. (Courtesy of John Masterson.)

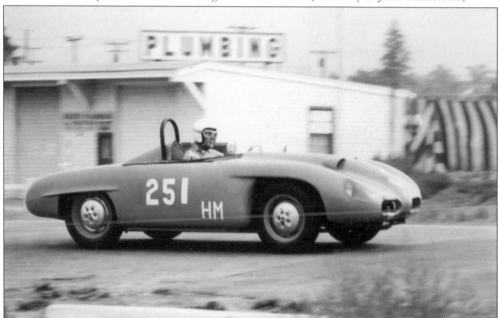

Among the many exotic sports cars at the Goleta races was the Devin Panhard, one of which is seen here. Powered by a Panhard 850-cubic-centimeter, two-cylinder, air-cooled engine, the car had a tube frame and a fiberglass body. Based in Fontana, California, builder Bill Devin produced a wide variety of glass-bodied race cars in the 1950s and 1960s. (Courtesy of John Masterson.)

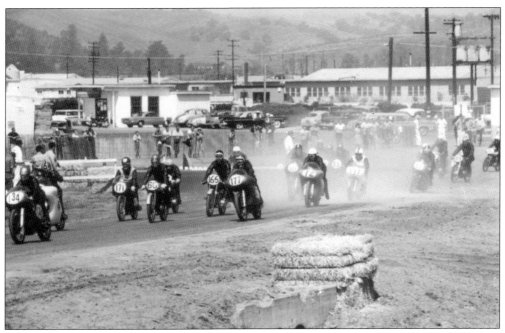

Grand prix motorcycle racing was another facet of the action at Goleta. Basically tourist trail or TT racing, races were made up almost entirely of European or British bikes with a few Hondas or Yamahas thrown in. The colorful machines with their full race fairings were always a popular attraction. (Courtesy of John Masterson.)

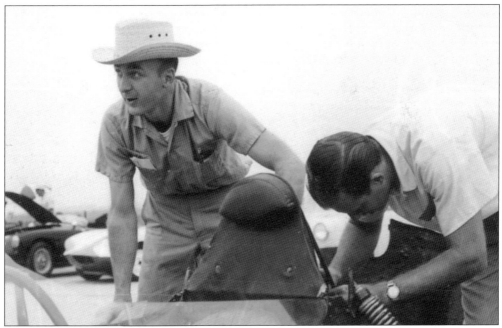

Norm Babcock (left) and Barry Atsatt make a few adjustments to Barry's Elva Formula Junior before a race at Goleta. Norm was another fixture of the Central Coast road racing scene. An Elva salesman and owner and a member of Scuderia Pacific, Norm was an enthusiastic supporter of all things road racing in the region. (Courtesy of John Masterson.)

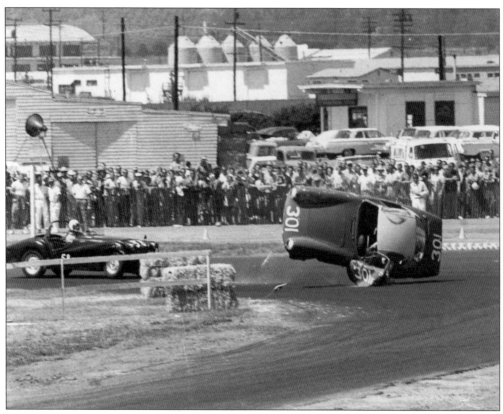

"Road Racing Is Dangerous!" was a phrase often seen in SCCA and CSCC race programs of the early 1960s, usually when outlining track safety rules. The driver of this unfortunate Lotus Elite demonstrates the fact before an aghast crowd at Goleta. Although the Elite had excellent handling characteristics and was difficult to spin or roll, this one has succeeded in a spectacular rollover, almost losing the driver's door in the process. Fortunately, the driver escaped serious injury and can be seen being led off the track at right below. (Both, courtesy of John Masterson.)

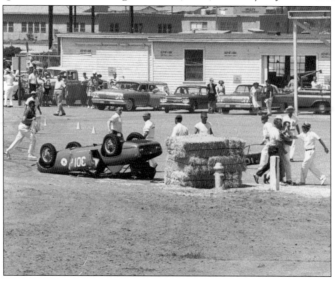

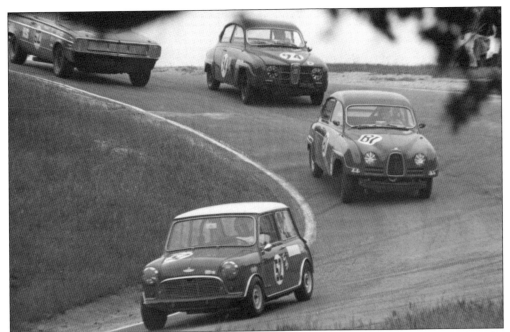

By the early 1960s, Barry Atsatt was in a job where he faced a long commute, so he purchased a new Morris Mini Cooper, primarily for its fuel economy. He soon discovered what a great race car it was too. Here, he is at Laguna Seca Raceway with a pair of Saabs and a Dodge Dart in hot pursuit. (Courtesy of Barry Atsatt.)

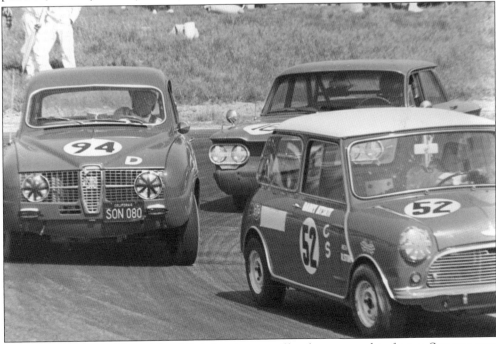

Barry was so successful with his Mini that he was offered a sponsorship from a Sonoma-area Morris dealership. The innovative Mini has been called one of the most influential designs in automotive history. (Courtesy of Barry Atsatt.)

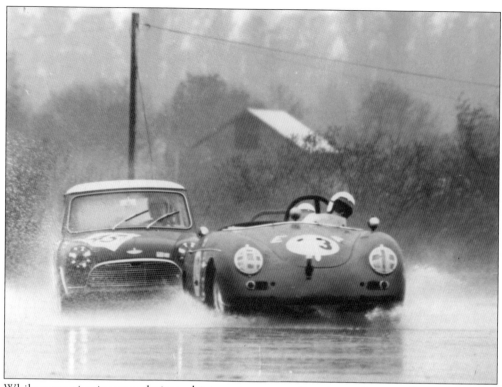

While competing in a race during a driving rainstorm at Cotati, near Sonoma, Barry discovered the superior wet-weather handling of the Mini's front-wheel-drive design. Here, he is crowding an open Porsche 356 Speedster. (Courtesy of Barry Atsatt.)

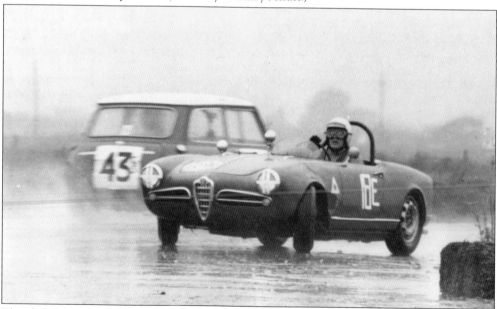

This slightly bent Alfa Romeo Giulietta Spyder is seen after spinning out during the storm at Cotati. The stunned and frightened expression on the face of the Alfa's driver says it all as Barry Atsatt speeds by in the background, going in the opposite direction. (Courtesy of Barry Atsatt.)

After campaigning the "Batmobile" and the Kurtis through a few race seasons, John sold them and took a break from racing for a short while. The break didn't last long, for in 1963, John acquired this Porsche 718/RS60 from Los Angeles dealer Otto Zimmer and was back in the game. The RS is pictured, painted in John's dark-blue livery, while getting ready to race at Del Mar Racetrack. The mid-engine Porsche 718 was developed from the famous Porsche 550 Spyder, with improved suspension and a restyled body. The lightweight RS60 model was powered by a 160-horsepower, 1.6-liter type 547/3 engine and featured a double-wishbone rear suspension, new to the 718 series. (Both, courtesy of John Masterson.)

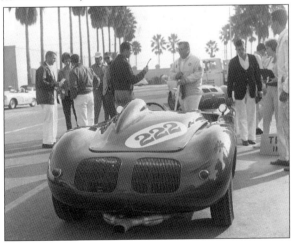

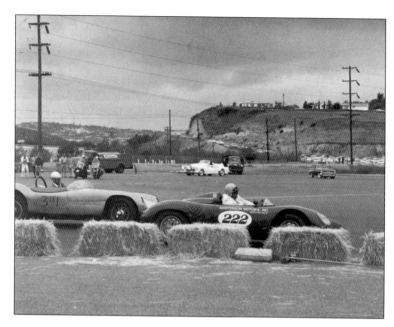

Here, John leans into a curve at Pomona, narrowly avoiding the hay bales. Of interest is the unusual white vehicle visible in the center background. It appears to be a creation of Coachcraft, an early Los Angeles–area custom shop that made special cars for Hollywood studios as well as "parade" cars like the one seen here. (Courtesy of John Masterson.)

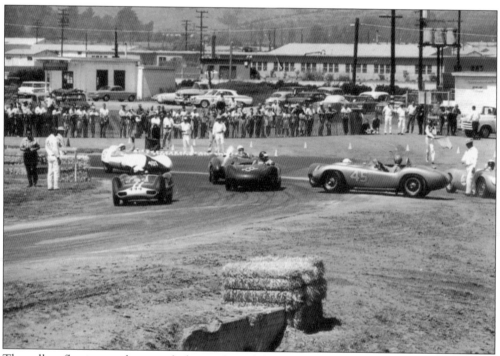

The yellow flag is waved to signify danger (at right) as the drivers slow past a group of cars that have run off the track around Turn Three at Goleta. Action like this, plus the colorful mix of exotic cars driven by world-class talent, brought the crowds back to Goleta year after year. (Courtesy of John Masterson.)

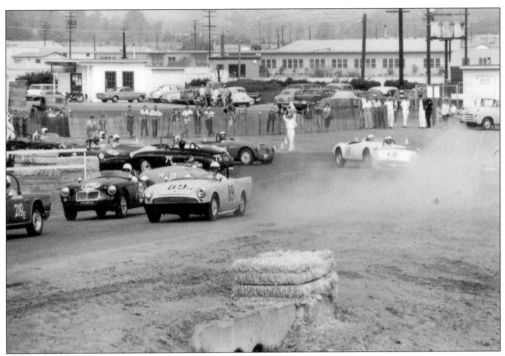

For this event, a field of mostly British production cars takes the track. A lone Porsche 356 Speedster, visible in the left center of the shot, appears to be headed in the wrong direction. Among other marques present in this image are MG, Sunbeam, Triumph, and Austin-Healey. (Courtesy of John Masterson.)

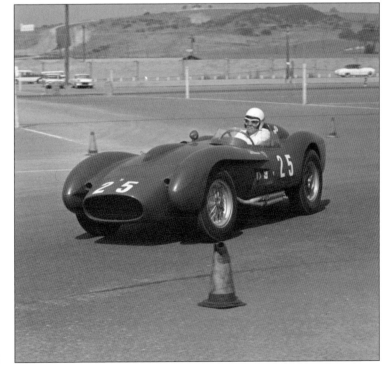

Scuderia Pacific stalwart Dick Brashear's Ferrari has been given a coat of red paint in this image, taken at Pomona. The classic lines of Ferrari's beautiful thoroughbred racer really pop out in this well-framed action shot. (Photograph by James W. LaTourette.)

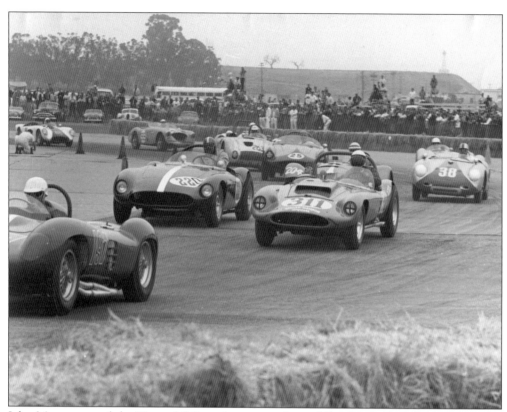

John Masterson and the "Batmobile" can be seen in the middle of a wonderfully mixed pack of exotics going around Turn Six at Goleta during the 1961 race season. The mesa visible in the background would soon become the site of the University of California, Santa Barbara campus. (Photograph by James W. LaTourette.)

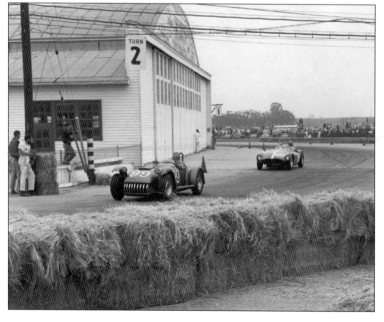

In this image, John chases a Kurtis around the old wooden hangar that made up Turns One and Two at Goleta. At a highly dangerous position at far right stands a young man in white coveralls with a movie camera, and a few feet away from him is a photographer; both are waiting for that perfect shot. (Photograph by James W. LaTourette.)

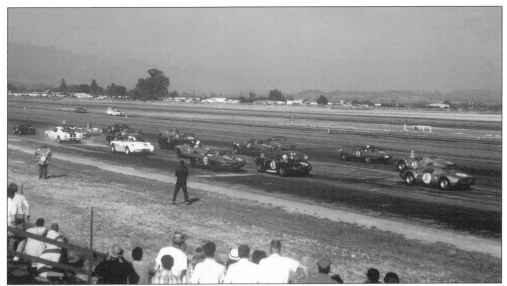

The road races at Goleta carried on until the late 1960s, when the growth of commercial air traffic at Santa Barbara Airport made racing events unsafe and impractical. In this shot from the last race season, a pair of Ferraris sits behind a group of production cars including Corvettes, Jaguars, a Shelby Mustang, and an AC Shelby. (Courtesy of Bob Mostue.)

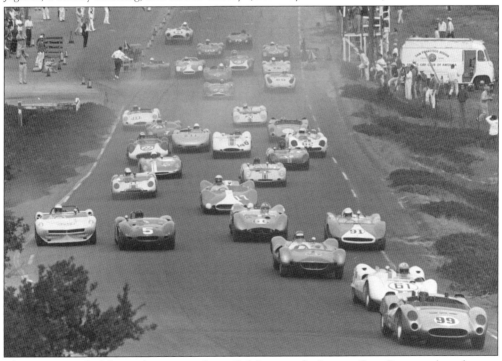

The crown jewel of the road racing tracks in California is the Laguna Seca Raceway (now known as Mazda Raceway Laguna Seca), located in Monterey County. Carved out of a corner of the vast Fort Ord Army base in 1957, the 2.2-mile course has been host to many world-class racing events throughout the years. This image from the late 1960s shows a large field of racers speeding past the starting line. (Courtesy of John Masterson.)

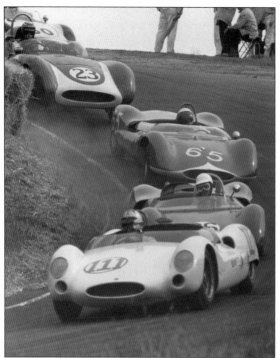

The most famous feature at Laguna Seca is a pair of downhill curves known as the "Corkscrew" (Turns Eight and Eight A), considered by many to be one of the most difficult turn combinations in the world of road racing. In this image, a Cooper Monaco leads the way down around the bend. (Courtesy of John Masterson.)

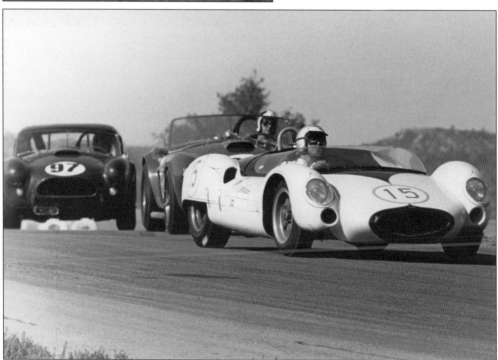

Television actor Dan Blocker (Hoss on the TV Western *Bonanza*) owned this Chevrolet-powered Cooper Monaco, shown in the lead at Laguna Seca. The Cooper Monaco combined a Cooper Formula 1 frame with an American V-8 engine to meet the demands for bigger, more powerful machines in the American road racing circuit. (Courtesy of John Masterson.)

Formula Ford racing superseded Formula Junior as a novice racing class in the mid-1960s. In this image from 1972, 20-year-old Stu Hanssen of Santa Ynez poses with his Lotus 51A Formula Ford racer at Laguna Seca Raceway. Stu has competed in five SCCA classes and holds three lap records. He currently races a 1984 Swift Sport 2000. (Courtesy of Stu Hanssen.)

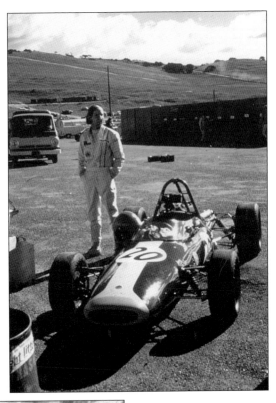

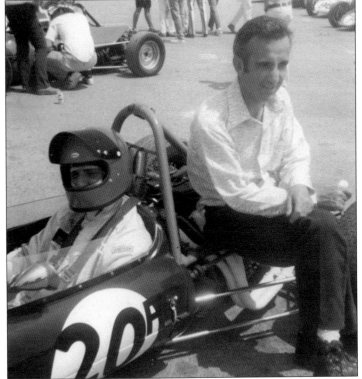

Hanssen is seated at the wheel before starting a race as his employer and mentor, John Heineman, perches precariously on the Lotus frame. British-born Heineman was a former Carroll Shelby employee and aeronautical engineer who owned HEI-MAC Racing and Sports Car Service in Goleta. (Courtesy of Stu Hanssen.)

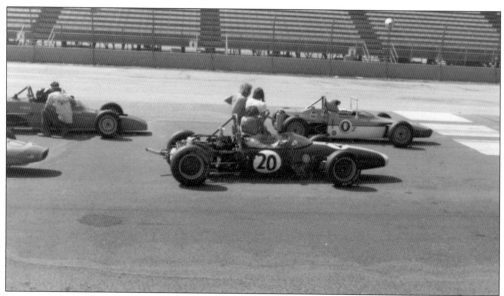

Hanssen's Lotus (No. 20) is seen before starting at Riverside. An early 51A, it was imported to the United States in 1967 by Dr. Jeff Shannon of Santa Ynez, who raced it in the final seasons at Goleta. When acquired by Hanssen in 1970, the car was powered by the original English Ford Cortina engine, although the Renault gearbox was replaced by a later Hewland unit. (Courtesy of Stu Hanssen.)

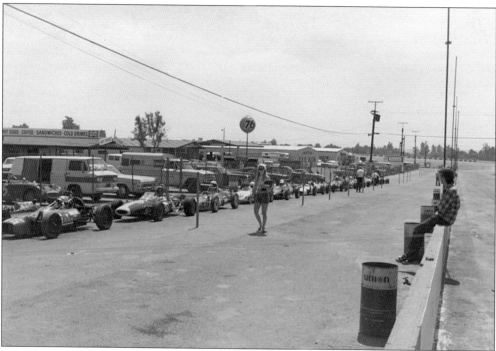

Formula Ford racing was conceived in England in the early 1960s and grew out of a requirement for a low-cost race car for Formula driving schools that could be owned and raced by novices as well. This line of cars waiting to qualify is pictured at Riverside Raceway sometime in the early 1970s. (Courtesy of Stu Hanssen.)

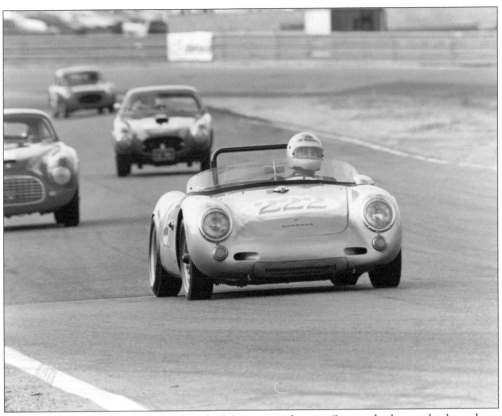

Two famous cars owned and driven by John Masterson at Laguna Seca and other tracks throughout California are pictured here. Above, seen leading a trio of Italian machines at Laguna Seca, is the 1.1-liter Porsche 550 Spyder that won its class at the infamous 1955 24 Hours of Le Mans race while being driven by Chevrolet Corvette designer Zora Arkus Duntov. Below is the former British and European Formula 2 Grand Prix champion HWM, a former mount of Sir Stirling Moss. Imported to the United States in the early 1950s, it had a long and varied career before Masterson acquired it. (Both, courtesy of John Masterson.)

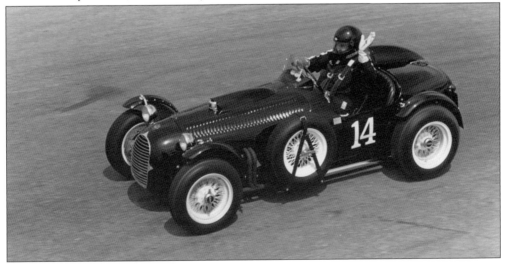

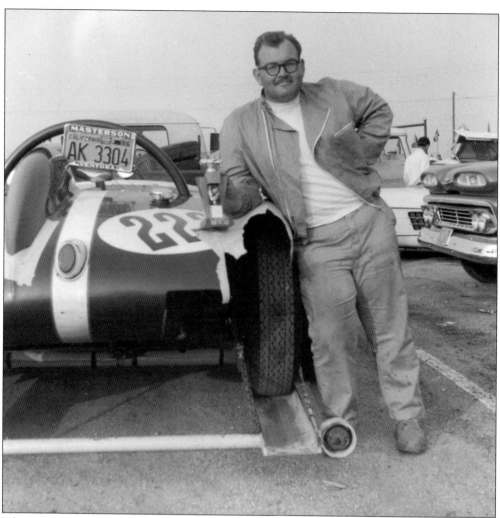

John Masterson continued to race until the mid-1960s, when growing business and family responsibilities forced him to leave the sport. He returned for a time in the 1980s, owning a trio of historic heritage racers. John retired as a car dealer and, after serving on the board of Community Memorial Hospital in Ventura, continues to live in Ventura. This image of him posing with his battered "Batmobile" after a day's racing at Goleta and proudly displaying his trophy personifies the spirit of the local amateur motor sport community. (Courtesy of John Masterson.)

Five

200 MPH Club

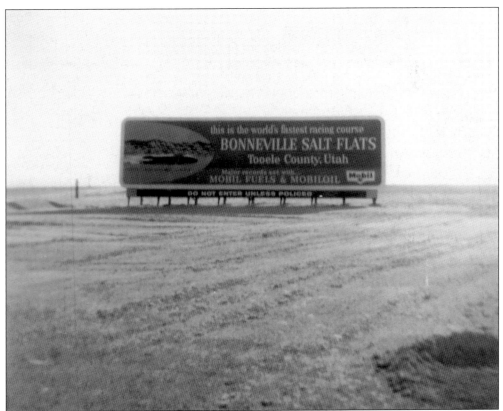

Of all the hallowed places in the world of motor sports, none have the allure and mystique of Bonneville Salt Flats in the state of Utah. A vast, flat, dry lakebed, it has been the site of motor sports events, and particularly land speed record attempts, since 1914. As automotive technology improved and cars got faster, an exclusive group known as the 200 MPH Club was formed in the late 1940s by those who had broken speed records in their respective classes. The Central Coast, particularly around Goleta, seems to have a larger percentage of members of that club living in a concentrated area than most other parts of the country. This chapter examines those people and the machines they broke their records in. (Courtesy of Arley Langlo.)

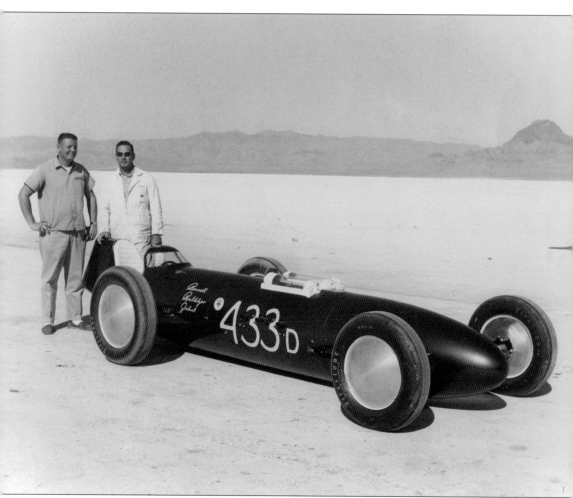

A locally built racer that had a long history at Bonneville was the D-class Bennett-Rochlitzer-Joehnck Special. The lakester's body, like many a lake racer, had its origins as an auxiliary fuel tank for a military aircraft, but rather than sitting within the tank, the driver was positioned behind the rear axle, as with a slingshot dragster. The frame was fabricated from welded seamless stainless steel tube. Bob Joehnck built the 327 Chevy engine, which was destroked to 302 cubic inches and fitted with Hilborn fuel injection. On its initial outing, Tim Rochlitzer drove the lakester to 231.958 miles per hour, which, while faster than the existing record, did not establish a new one. Ernest Bennett stands at left, and Rochlitzer is at right. (Courtesy of Arley Langlo.)

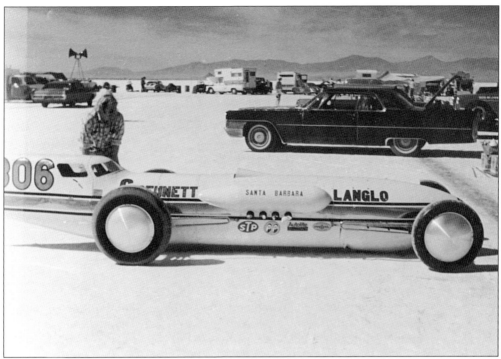

Tim Rochlitzer parted ways with Bennett in 1971, and throughout the 1970s, Arley Langlo (above) and then Gil Ruiz assumed part ownership with Bennett. In 1981, Goleta resident Seth Hammond purchased the lakester and almost immediately set a class record of 259 miles per hour, which also earned him entry into the 200 MPH Club. The lakester would stay in the Hammond family for the rest of its career, always powered by Chevrolet small-block engines. Over time, the lakester wore a variety of color schemes, the first being all black, as seen here posed against a Bonneville landmark, the famous Floating Mountain. (Above, courtesy of Arley Langlo; below, courtesy of Seth Hammond.)

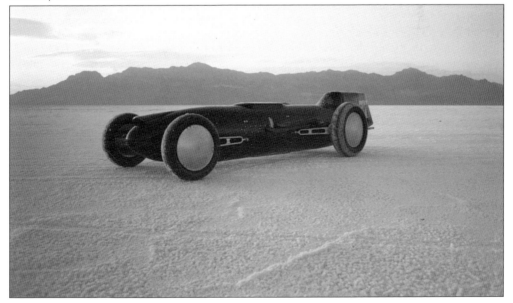

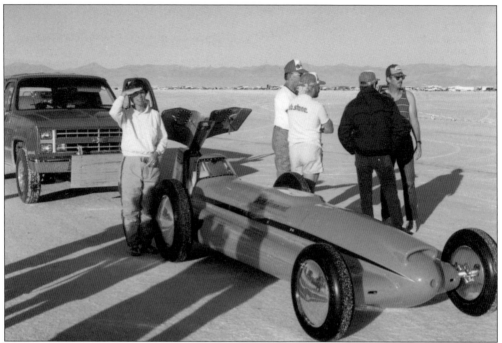

Hammond's wife, Tanis (pictured in both images), was also very active at Bonneville. She joined the 300 MPH Club by being the first person to take the Special over 300 miles per hour and the first person to do it in a tank racer. These two images show the different modifications Hammond made to the canopy, from a butterfly type pictured above to the arrangement seen below. Note also the nose air scoop added to improve the normally aspirated alcohol-burning engine's breathing. (Both, courtesy of Seth Hammond.)

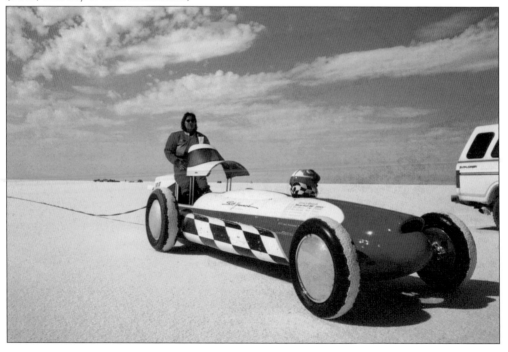

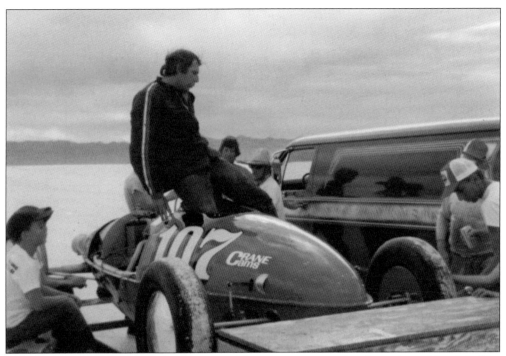

Seth Hammond, the Special's owner, is one of the most prominent local members of the club. The Goleta business owner has been a fixture at Bonneville for over 35 years and set many records. He is seen here in his first Bonneville mount, the famous "Scotty's Muffler" tank car, in which he set records in 1976 and 1978. (Courtesy of Seth Hammond.)

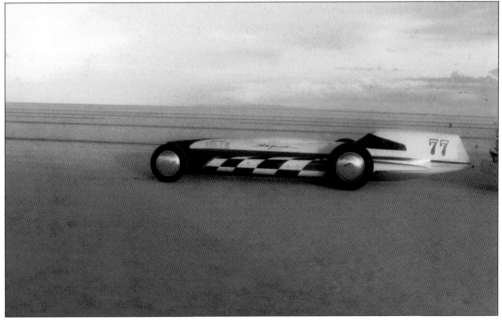

Here is a shot of the Special in motion, just after it has separated from the push car. The veteran lakester met a fitting end on the lakebed in 2003 when it was wrecked due to track conditions while at a speed of over 324 miles per hour. (Courtesy of Seth Hammond.)

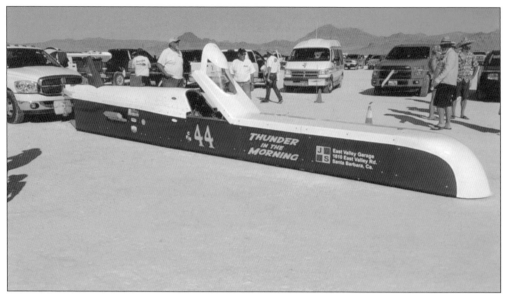

Local racing legend Fred Dannenfelzer has been a regular at Bonneville Speed Week for over 50 years. Holder of the land speed record for open-wheel cars (at 366 miles per hour), he currently runs this Chrysler Hemi–powered C-class streamliner, "Thunder in the Morning." Streamliner-type lake racers differ from traditional lakesters in that the wheels are completely enclosed within the car's body. (Courtesy of Fred Dannenfelzer.)

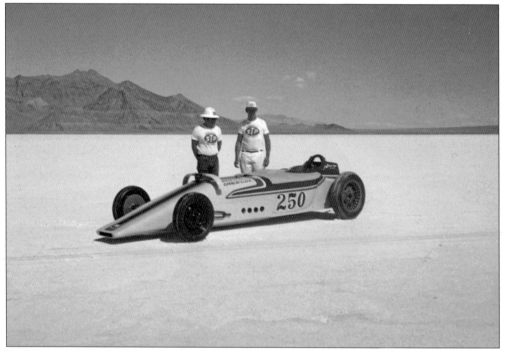

Fred Dannenfelzer (right) and Gil Ruiz (left) built this AA-class modified roadster for trials at Bonneville. Sam Foose was responsible for building the body ahead of the firewall as well as the painting and finishing. Note the small airfoil mounted just behind the front wheels. (Courtesy of Sam Foose.)

Like many lake racers, the roadster would be modified over the years in the never-ending effort to add a few more miles per hour to the record. Seen here after a run and speckled with salt from the lake surface, it is hard to believe that the car is based on a 1923 Ford Model T roadster. (Courtesy of Sam Foose.)

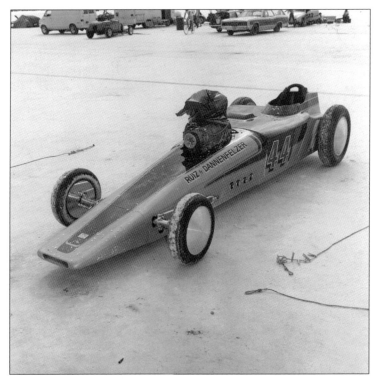

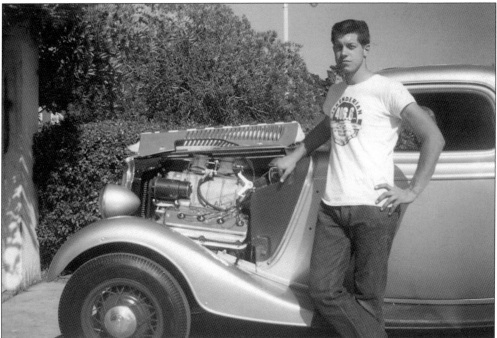

Arley Langlo (Santa Barbara High School, 1959) is a member of the 200 MPH Club and former member of the Dusters car club who has raced countless times, both on the drag strip and at Bonneville. He is seen here with his first hot rod, a 1933 Ford coupe he acquired as a stock machine and built into this Hemi-powered racer. (Courtesy of Arley Langlo.)

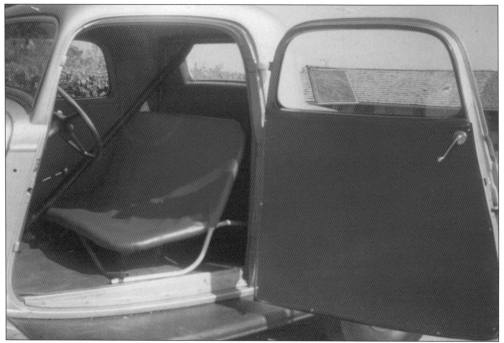

This interior shot of Arley Langlo's 1933 Ford coupe shows the lengths some people will go to in order to lighten their cars. The seat is simply a sheet of vinyl stretched over a light tube frame. Getting 123 miles per hour and an elapsed time of 12.33 seconds at the strip, the machine weighed in at 2,800 pounds. (Courtesy of Arley Langlo.)

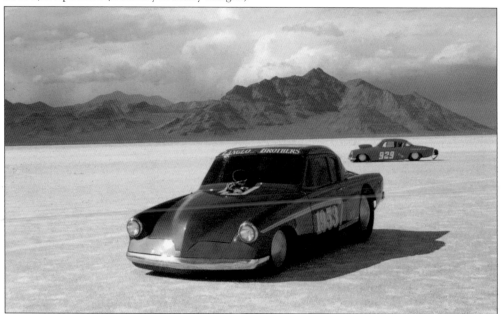

Arley and his brother Ed went partners on this 1953 Studebaker when going for the B Fuel Coupe–class record in 1986. Powered by an early 301-cubic-inch Chrysler Hemi equipped with a GMC 671 blower and Hilborn injection, Ed Langlo drove the Studebaker to 235 miles per hour against a 221-mile-per-hour national record on his qualifying run. (Courtesy of Ed Langlo.)

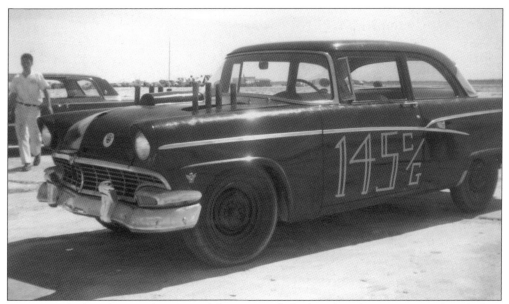

In 1960, Arley bought a stock 1956 Ford from Tony Shaloob and used it for a trip to the salt flats. Tom Swiggam's 312-cubic-inch Ford V-8 was installed. Note the "zoomie" exhaust pipes protruding through the top of the hood. After running the car as a gasser at Bonneville, Arley returned it to its stock condition and used it as a daily driver. (Courtesy of Arley Langlo.)

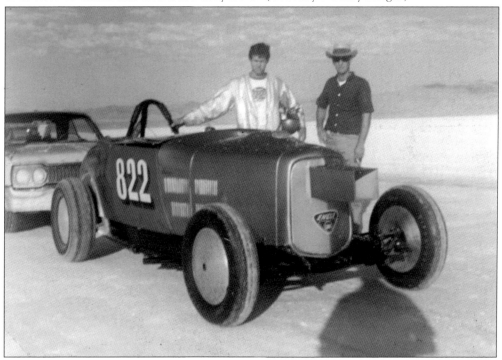

Arley joined the 200 MPH Club in 1966 when he drove the Quinton-Richards Special, seen here, to an AA-class record of 206 miles per hour. Arley Langlo is standing at right, and the car's co-owner, Bob Richards, is at left. The boxlike structure extending from the grill shell is a duct to improve airflow into the engine. (Courtesy of Arley Langlo.)

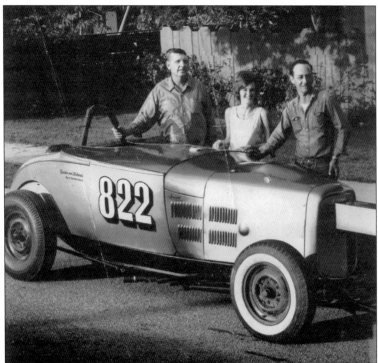

Jack Quinton (left), and Bob Richards (right), both longtime participants in the Central Coast drag racing scene, built this 1929 steel-bodied Ford roadster, and the Chrysler Hemi engine was assembled by Jay Roach of the J&S Garage in Montecito. (Courtesy of Bob Richards.)

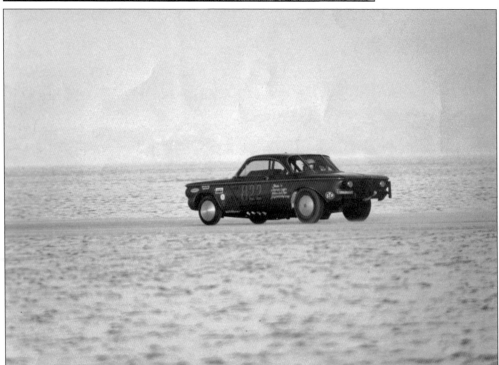

In 1969, after running the car as a roadster, Quinton and Richards wanted to go for the class record for coupes and so replaced the Ford body shell with a Chevrolet Corvair. It is seen here on a run down the salt flat. (Courtesy of Bob Richards.)

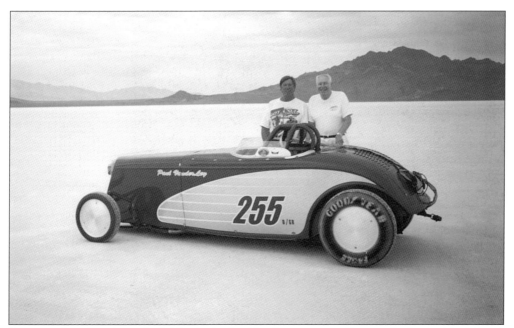

Veteran of track and strip Jack Mendenhall, of Buellton, went to Bonneville for the 2004 Speed Week and his son, Mark, won the D-Gas Roadster Class with a speed of 213.252 miles per hour. Paul Vander Ley built the engine that powered this classic open-wheel roadster. Jack stands at right, and his son, Mark Mendenhall, is at left. (Courtesy of Mark Mendenhall.)

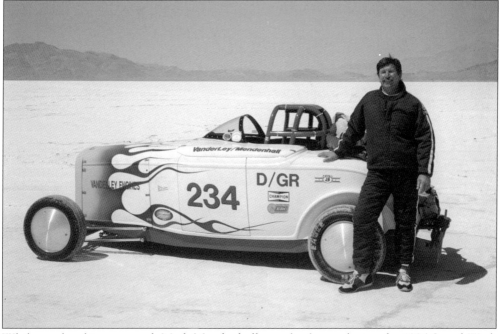

While not breaking a record, Mark Mendenhall was the fastest during the 1996 Speed Week driving this D-gas roadster to 210.114 miles per hour. Jack Mendenhall and Biloxi, Mississippi–based engine builder Paul Vander Ley co-owned the 1932 roadster, and Vander Ley Engineering built the 305-cubic-inch Pontiac V-8 engine. (Courtesy of Mark Mendenhall.)

Many interesting details abound in this 1966 image from Seth Hammond and Arley Langlo's trip to Bonneville Speed Week. Note how the C-class gas roadster has had the driver's position centered and moved over the rear axle and also the clean and professional finish to the car. Also check out the Ford Falcon in the background. (Courtesy of Seth Hammond.)

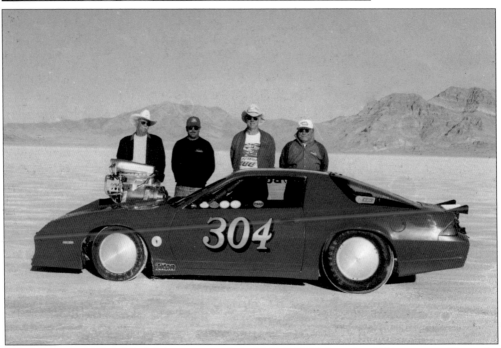

Santa Barbara resident Mark Johnson joined the 200 MPH Club in this 1980s-vintage Chevrolet Camaro. The engine is a fairly rare Donovan-built 468-cubic-inch early Chrysler Hemi. (Courtesy of Mark Johnson.)

All types of race cars could be seen at Bonneville making record attempts in the various classes, although sometimes it seemed like it was more for the publicity than anything else. Southern California racing legend Mickey Thompson took his Indy car, seen here, out on the flats for a run during the late 1960s. (Courtesy of Arley Langlo.)

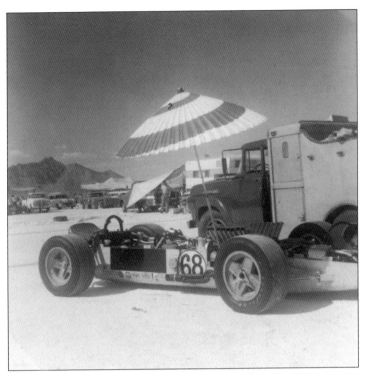

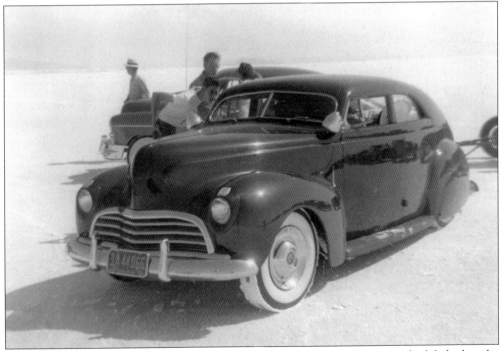

While not strictly a race car, this custom 1940 Ford made an appearance on the lakebed in the early 1950s, although it is doubtful the owner risked damaging all that paint and bodywork by making a serious speed run. The big custom must have made quite a sight moving across the salt flat. (Courtesy of Lee Hammock.)

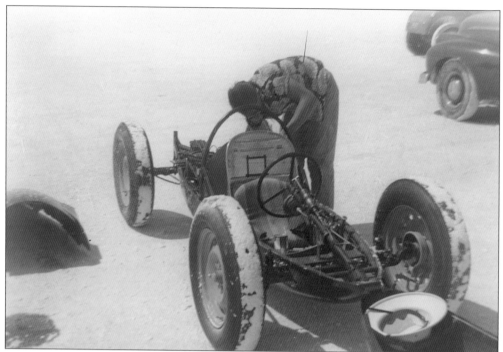

Tank racers were a common sight at Bonneville back in the 1950s. Military surplus auxiliary fuel tanks for aircraft were readily available in Southern California, cheap, and adapted easily as body shells for lake racers. This image shows one that has had the upper shell removed, exposing the very cramped interior. (Courtesy of Lee Hammock.)

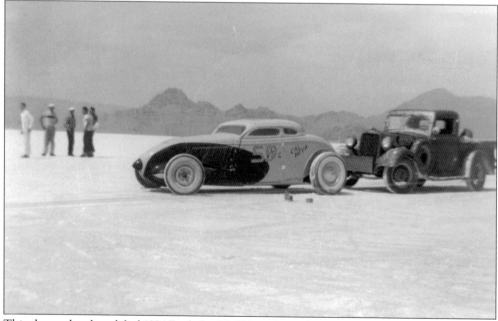

This chopped and modified 1934 Ford, the "Cal-Neva Special," is staged and ready for its qualifying run in 1954. Note the push truck, and in the background is Floating Mountain, a feature common in most pictures taken on the lakebed. (Courtesy of Lee Hammock.)

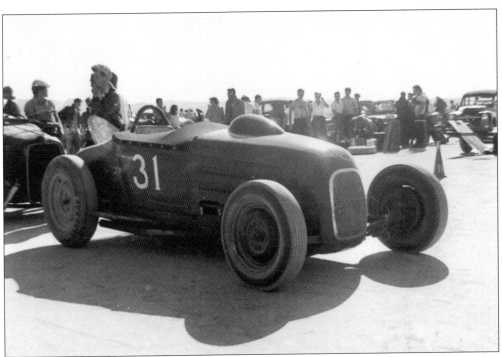

Before Bonneville, El Mirage dry lake was the main venue for speed trails, especially for hot-rodders from Central and Southern California. Acceleration runs sponsored by the Southern California Timing Association, and before that the Western Timing Association, began there in the late 1930s and ran until the early 1950s, when the action moved to Utah. Here are a pair of images of Model T roadster-based lakesters, typical of the type seen regularly at both Bonneville and El Mirage. (Above, courtesy of Lee Ledbetter; below, courtesy of Lee Hammock.)

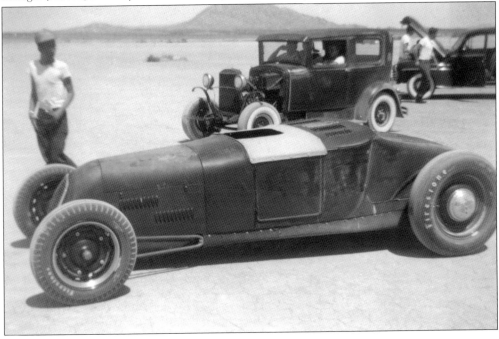

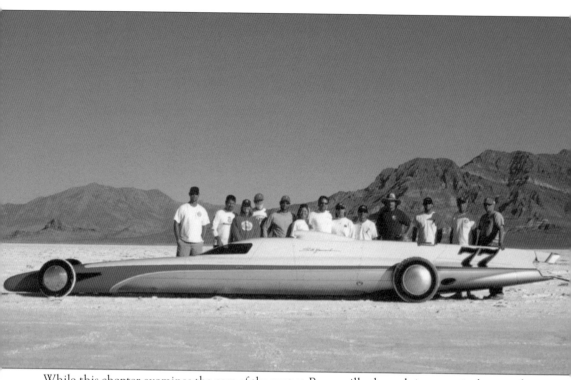

While this chapter examines the cars of the past at Bonneville through imagery, it closes with a look at the type of machine that is Bonneville's future with this image of Seth Hammond's No. 77. This 31.5-foot, state-of-the-art lake racer was designed by Hammond's son, Channing, and built in the Hammonds' shop in Goleta. The frame is constructed of one-and-five-eighths-inch 4130 chromoly tube and has been designed with a 260-inch wheelbase for high-speed stability. The engine is an incredible 632-cubic-inch Chevrolet, generating an awesome 1,248 horsepower at 7,300 revolutions per minute while burning racing gasoline. Seth has run the lakester up to 323 miles per hour, and the Hammond family plans be at Bonneville during the upcoming seasons, carrying on a long tradition. (Courtesy of Seth Hammond.)

Six

PEOPLE AND PLACES

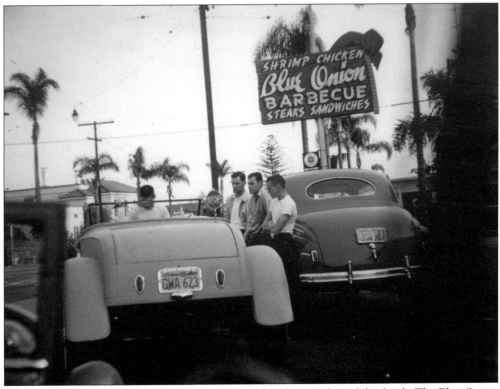

This image may trigger memories among some of the older readers of this book. The Blue Onion drive-in restaurant at Valerio and State Streets in Santa Barbara was the mecca for local hot-rodders. In this picture, a group of aficionados hangs out while discussing the merits of the roadster at left. The Blue Onion closed many years ago, and most of the other places where motor sports addicts congregated are gone too. In this final chapter, many of the individuals, places, and cars, now mostly gone, that contributed to the varied history of motor sports on California's Central Coast are illustrated. (Photograph by Dick Griffin.)

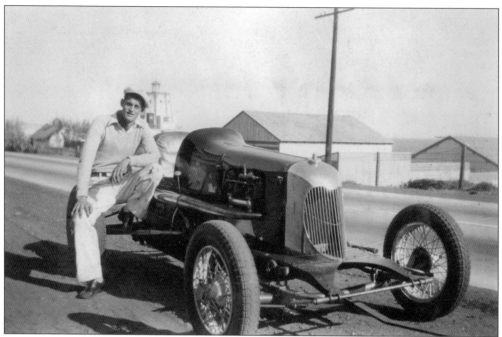

Santa Barbara native Clarence "Sundown" Langlo was raised on his family's ranch in Winchester Canyon and operated a garage and brake shop on Ontare Road. An early motor sport enthusiast, Langlo was a charter member of the Santa Barbara Motorcycle Club and raced a Riley-Ford-powered sprint car, pictured here sometime in the early 1930s. Above, Clarence is parked on Shoreline Drive in Santa Barbara. Just visible over his left shoulder is the Santa Barbara Lighthouse. Below, the sleek black sprint car is shown to better advantage while parked at a Goleta Airport hangar. (Both, courtesy of Ed Langlo.)

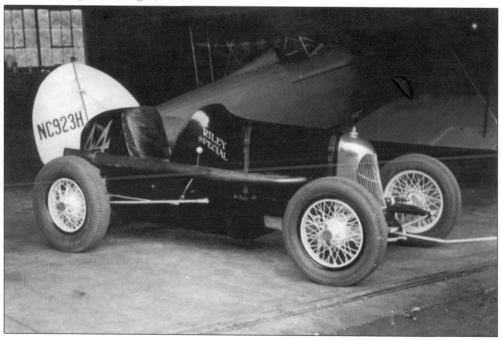

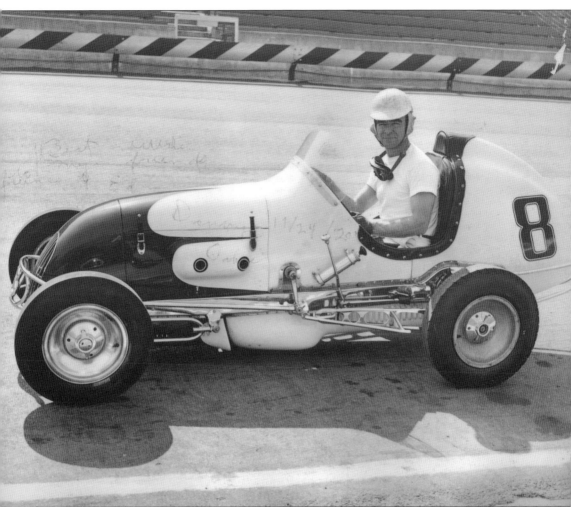

"Dapper" Danny Oakes was another local who plied the sprint and midget car circuit. A favorite with the crowds at regional tracks like Ascot Legion, Gilmore Stadium, and Irwindale, the good-looking Oakes was very successful, at one time becoming the National Sprint Car Champion. He was not a lead-footed driver but drove in a careful and calculated fashion that usually won him the race. So successful was Oakes that he was able to lead a very comfortable life and retire on his earnings as a professional sprint car racer. (Courtesy of Ed Langlo.)

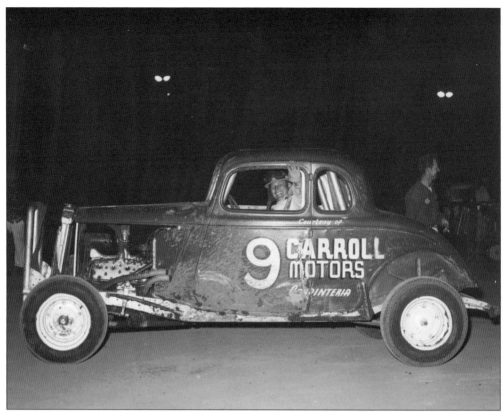

The Thunderbowl, in Carpenteria, was one of the most popular dirt tracks in the region during the 1940s and 1950s. It was best known as home to jalopy racing, which was a particularly rough-and-tumble type of motor sport. Now a Carpenteria schoolteacher, the driver seen here drove under the pseudonym R. Spencer to avoid scandal. Below, Spencer grins for the camera as he climbs from the wreckage after his car went through the board fence at the bluff-top racetrack. (Both, courtesy of Lee Hammock.)

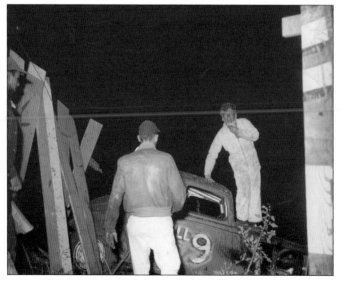

As noted elsewhere in this book, motor sports can be dangerous, with serious injuries and even fatalities sometimes occurring. Ambulances were present (if not always functional) at every racetrack and drag strip in the region. This grim-faced driver stands at the ready by his Cadillac ambulance at the Carpenteria Thunderbowl. (Courtesy of Lee Hammock.)

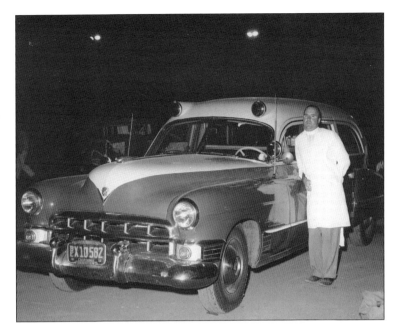

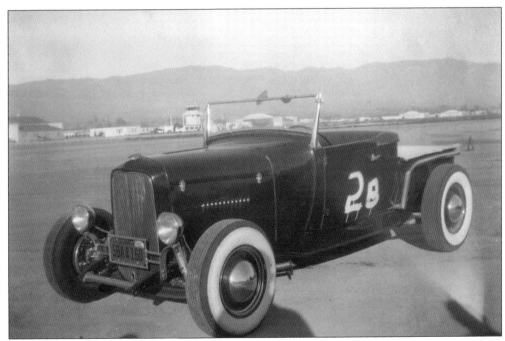

Santa Barbara Municipal Airport was a magnet for local hot-rodders in the late 1940s, and the first legal drag races were held there. This nicely appointed 1929 Ford Model A roadster pickup is seen at the airport before a race. Note the cut-off exhaust visible over the rear fender. (Courtesy of Ed Langlo.)

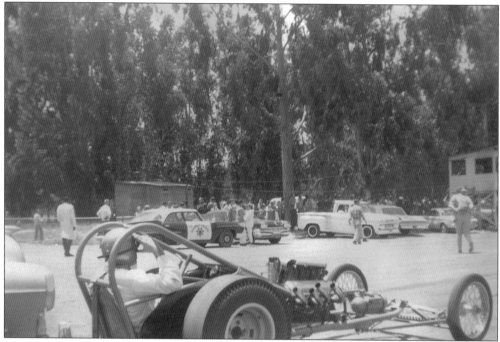

Santa Maria Drag Strip was, for over 10 years, the biggest venue for drag racing in the region. Founded in 1953 by Jerry Gaskill of the Santa Maria Dragons car club, the strip attracted drag racers from all over the country. This view shows the pit area with the timing tower visible at extreme right. (Courtesy of Arley Langlo.)

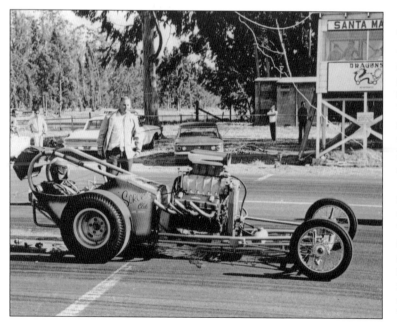

This image shows the starting line at Santa Maria. Drag strip founder Jerry Gaskill appears to be standing second from left inside the timing tower. Although the strip closed in the mid-1960s, some vestiges remain, like the cement bunker visible in the right center background, and the eucalyptus trees still grow in abundance. (Courtesy of Walter Schuyler.)

Walter "Skip" Schuyler, of Lompoc Model T Club fame, built and raced several cars over the years. Besides Model Ts, there were oval track racers, jalopies, and drag racers. His first drag racer, the "Stinger," is illustrated here. It was powered by a Cadillac engine and obviously well built, as can be seen in the images, but little else is known about this mid-1950s drag racer. Note how the engine and driver are completely enclosed in a formed and louvered sheet metal nacelle. The "Stinger" was wrecked in a nonfatal accident on the strip at Santa Maria in the mid-1950s. (Both, courtesy of Lee Ledbetter.)

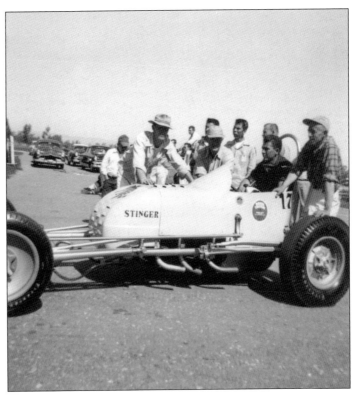

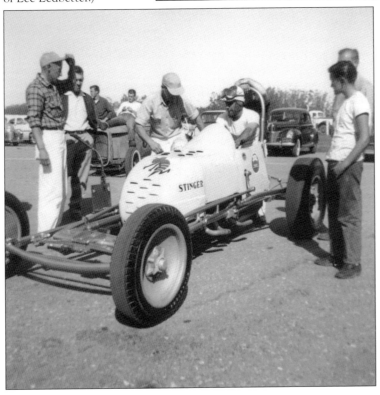

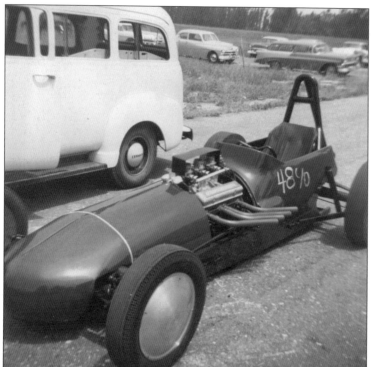

This interesting dragster belonged to Jack Chard. Built in Santa Maria and powered by a small-block Chevy 283, the car's frame was fabricated from galvanized plumbing pipe, and the steel body was formed out of the fenders and body panels of wrecked cars. Despite being quite heavy, it did well at the drag strip. (Courtesy of Arley Langlo.)

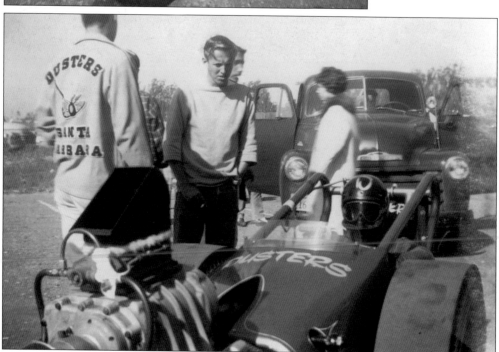

The Dusters car club fielded this B-class blown fuel dragster, called the "Spirit of Santa Barbara." In this image from June 1962, Keith Perington (left) looks on as Dick Griffin gets ready to pilot the racer to the Top Eliminator slot with a top speed of 180.36 and an elapsed time of 8.41 seconds in the quarter mile. (Courtesy of Arley Langlo.)

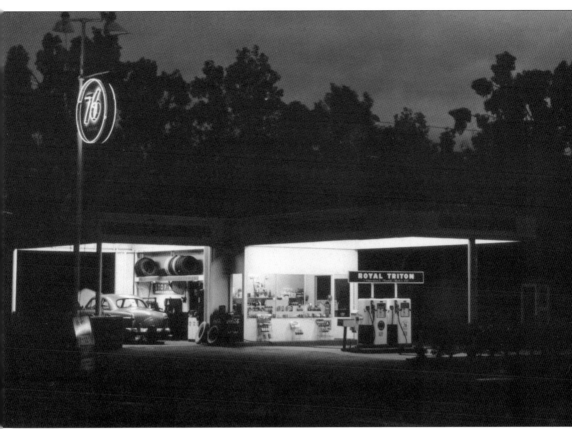

This evocative predawn image of Fred Elizalde's Union 76 service station at the corner of Coast Line Village and Hermosillo Roads in Montecito was taken in the late 1950s. The all-night shift at the local gas station was a coveted job for some hot-rodders, who welcomed the chance to work on their cars in a fully equipped garage with few interruptions. Note the shiny early-1950s "shoebox" Ford in the repair bay and the generally neat and clean appearance of the station. (Courtesy of Ed Langlo.)

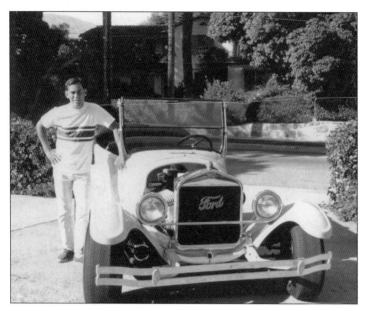

Roger Battistone is a member of the Santa Barbara community well known for both his car collection and his philanthropic efforts. Here, he poses in 1965 with his 1927 Model T touring car. Roger purchased a wrecked Corvette from a friend and installed the 327 engine, four-speed transmission, and rear end in the canary-yellow tub himself, making for a pretty cool hot rod. (Courtesy of Roger Battistone.)

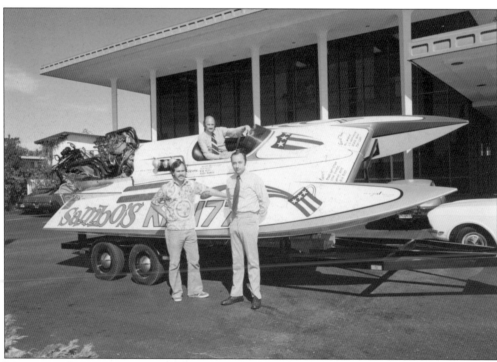

Many years later, Battistone would own and race this tunnel-hull drag boat. Keith Black built the Chrysler Hemi engine, and the hull was painted by Sam Foose. The name "Sambo's" and the coffee cup painted on the hull refer to the Battistone family–owned chain of restaurants. The boat raced successfully at local venues like Parker Dam, Puddingstone Reservoir, and Lake Elsinore. (Courtesy of Roger Battistone.)

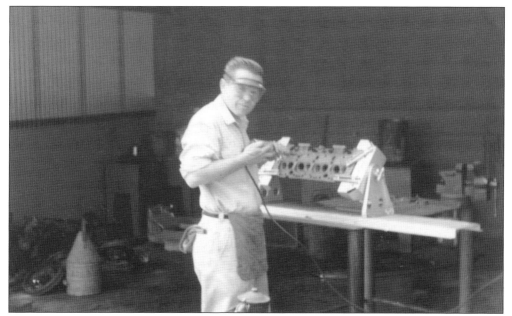

No chronicle of the region's motor sport history would be complete without mentioning Bob Joehnck. Founder of America's first drag strip at Goleta, Bob is better known as a sought-after builder of racing engines and racing cars. He is seen here in a typical pose about to grind a few valve seats. (Courtesy of John Masterson.)

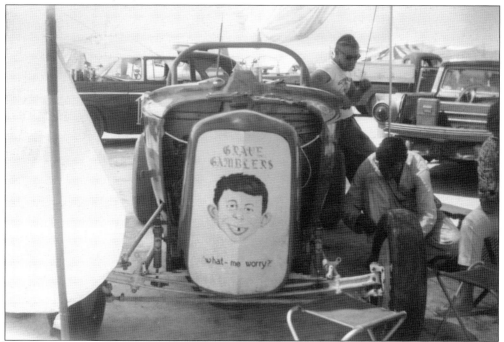

Tom Swiggam leans against Jerry William's roadster as Fred Dannenfelzer works on some small part. Note the grill shell insert that belonged to Fred and featured *Mad* magazine's mascot, Alfred E. Neuman, and his motto "What – me worry?"—which described the Grave Gamblers car club's attitude towards the dangers of racing. (Courtesy of Arley Langlo.)

The Gibraltar Dam run, an annual off-road race held by the Santa Barbara Motorcycle Club the first Saturday in January, ran from 1925 until 1961. Over the years, the 25-mile course took various routes to wind up at the Gibraltar Dam Campgrounds, where an after-race party was held. Bob Mullaney attempted to revive the tradition in 1968, and a field of 35 riders ran a course starting at the Upper Oso Campground along Paradise Road to Gibraltar Dam. The winner that year was Santa Barbara resident Bob Mostue, seen riding his BSA 650 Hornet above and proudly showing off his trophies below. (Both, courtesy of Bob Mostue.)

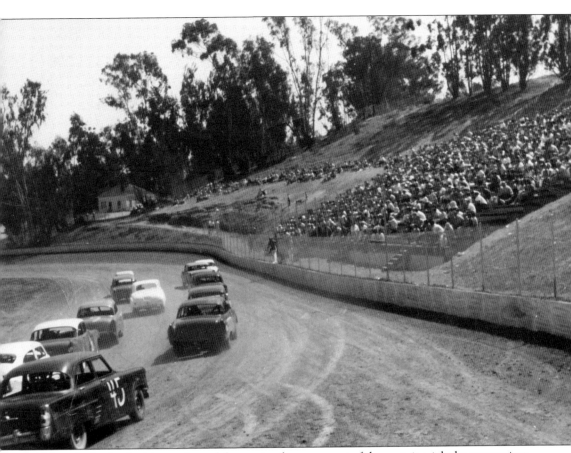

Although this book visits tracks and drag strips that are a part of the past, it might be appropriate to end it with a look at part of the history of a Central Coast racing venue that is still in operation. Santa Maria Speedway was founded in 1964 by electrical contractor and racing fan Doug Fort. Fort sold his contracting business to purchase land along a Nipomo Creek bottom near Highway 101 because he wanted to build a racetrack. He was fortunate to discover that the bottomland was composed of clay, which made an ideal track surface. This view shows the track in its first year of business. Today, the one-third-mile oval track hosts a wide variety of racing events, as it has for over 50 years. (Courtesy of Mark Mendenhall.)

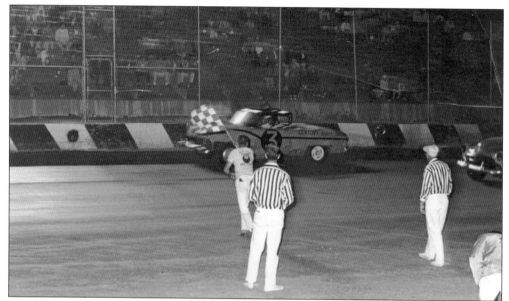

The track is mostly known for sprint and midget car racing, but for many years, stock cars races were crowd-pleasing events. On the Central Coast, these races were basically a carry-over from jalopy racing, which was very popular during the 1940s and 1950s. Here, flagman Lyle Powe drops the checkered flag to end a night race. (Courtesy of Mark Mendenhall.)

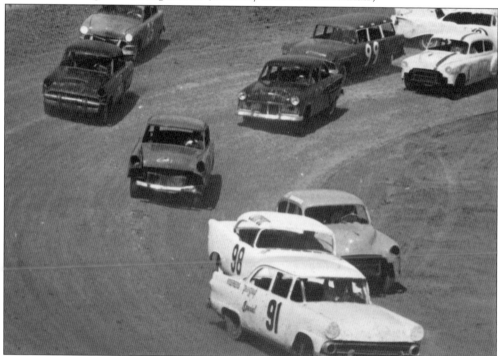

Using mainly 1950s-vintage American cars, since most of the 1934 Fords in the area had been destroyed by jalopy racing, local stock car races were chaotic and colorful affairs. In this image, a mixed bag of Detroit iron thunders around the clay track surface. Note the Chevrolet at upper right that is pointed in the wrong direction. (Courtesy of Mark Mendenhall.)

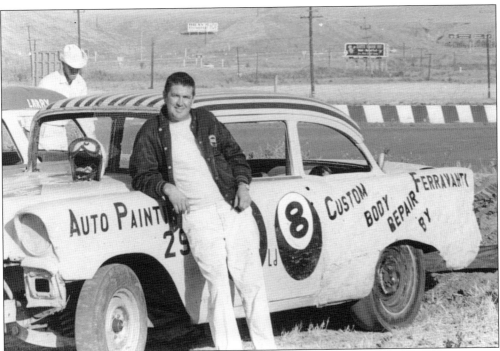

"Skiddin' Sid" McClain, pictured here, smiles for the camera as he poses with his Chevrolet stock car, the "Eight Ball." Affable and popular with the crowd, McClain was an aggressive driver who was known for his spinouts and who usually finished in the top three. This view was taken with a view looking east towards Nipomo Creek and Highway 101. (Courtesy of Mark Mendenhall.)

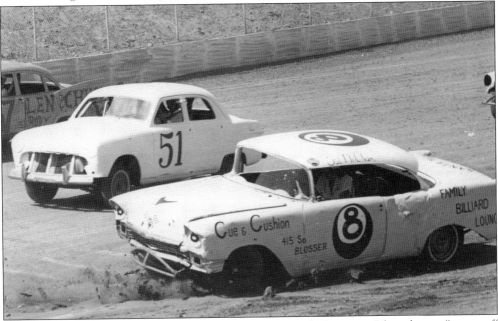

Sid and the "Eight Ball" are seen in action at Santa Maria as he begins to "close the gate" or cut off a shoebox Ford. The Chevrolet's suspension, frame, engine, and body were all replaced at various times due to damage incurred by Sid's rough driving style. (Courtesy of Mark Mendenhall.)

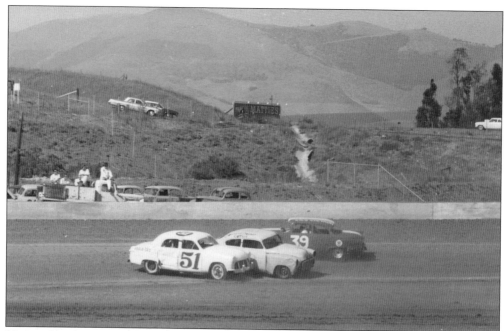

Mix-ups like this were common in the early jalopy-style stock car races at Santa Maria; it is difficult to tell which cars are going in the right direction. Although rough in appearance, most stock cars were serious racing machines underneath all that bent metal. (Courtesy of Mark Mendenhall.)

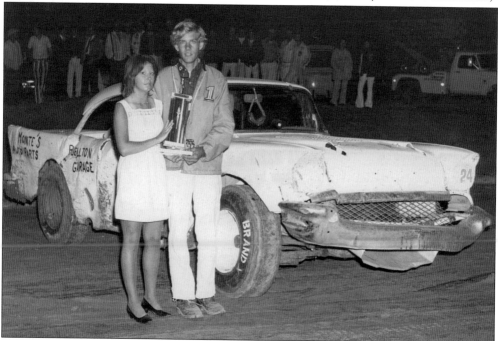

Stock car races at Santa Maria were in two classes: novice and sportsman (for the more experienced drivers). In this image, youthful pit crew member Steve Neilson of Solvang accepts the dash race trophy for driver Jack Mendenhall from trophy girl Patti Lee of Lompoc. (Image by R. Wat, courtesy of Mark Mendenhall.)

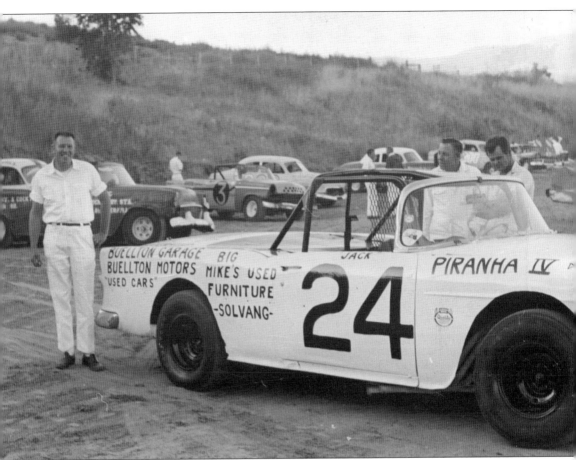

One of the big dogs at Santa Maria speedway was Jack Mendenhall. Owner of Buellton Garage and Tow Service, Jack was well known at drag strips and racetracks all over the region. A member of the 200 MPH Club, Jack also campaigned his gas dragster, the "Pea Soup Special," throughout California with great success. For stock car racing, Jack ran a series of "tri-five" Chevrolets named "Piranha." In this image from 1966, Jack poses with the fourth version of the "Piranha" while standing in the crowded pit area at Santa Maria. (Courtesy of Mark Mendenhall.)

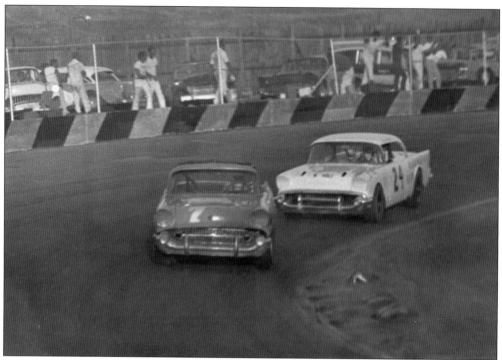

Over time, stock cars departed from their jalopy racer roots and gained a more polished appearance. Here, a later version of Mendenhall's "Piranha" closes in on another Chevrolet on the track at Santa Maria sometime in the 1970s. Note how the look of both cars differs from earlier racers. (Courtesy of Mark Mendenhall.)

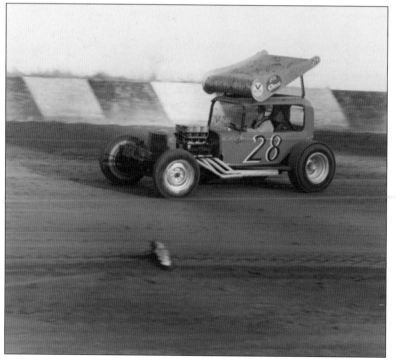

Super modified sprint car racing was and still is another facet of the scene at Santa Maria Speedway. Usually powered by Chevrolet small blocks and wearing cut-down jalopy bodies, the big sprints put on an exciting show for the crowds. The big wing mounted on the roof helped keep the short-wheel-based racer's nose down on the track. (Courtesy of Mark Mendenhall.)

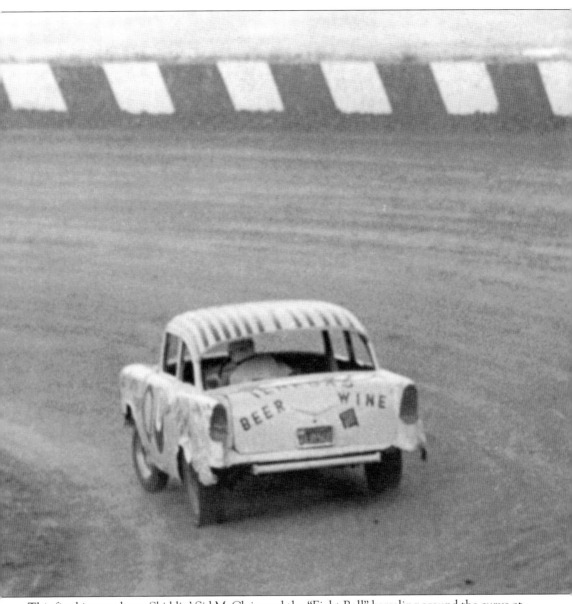

This final image shows Skiddin' Sid McClain and the "Eight Ball" barreling around the curve at Santa Maria Speedway. While greatly diminished from the glory days of the 1950s, 1960s, and 1970s, motor sports and hot rod culture live on along the Central Coast. Santa Maria Speedway is still putting on races, and there is a strong popular movement to bring drag racing back to the region by establishing a drag strip and motor sports park in the city of Lompoc, home to the Model T races of the 1930s and 1940s. In a region like the Central Coast, where the racing tradition is passed along from generation to generation, motor sports will certainly continue. (Courtesy of Mark Mendenhall.)

DISCOVER THOUSANDS OF LOCAL HISTORY BOOKS FEATURING MILLIONS OF VINTAGE IMAGES

Arcadia Publishing, the leading local history publisher in the United States, is committed to making history accessible and meaningful through publishing books that celebrate and preserve the heritage of America's people and places.

Find more books like this at
www.arcadiapublishing.com

Search for your hometown history, your old stomping grounds, and even your favorite sports team.